POSTCARD HISTORY SERIES

Owasco Lake

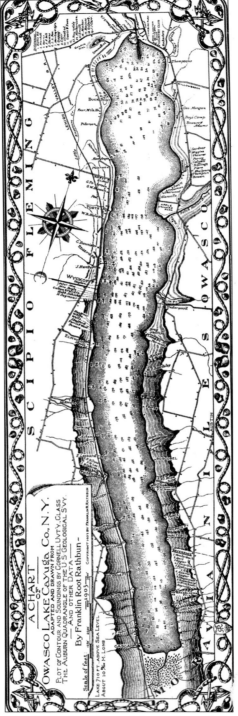

This map of Owasco Lake was drawn in 1903 and shows the various the names of many points and private houses then located along the la'

POSTCARD HISTORY SERIES

Owasco Lake

Paul K. Williams and Charles N. Williams

ARCADIA
PUBLISHING

Published by Arcadia Publishing
Charleston SC, Chicago IL, Portsmouth NH, San Francisco CA

Printed in the United States of America

Library of Congress Catalog Card Number: 2002110470

For all general information contact Arcadia Publishing at:
Telephone 843-853-2070
Fax 843-853-0044
E-mail sales@arcadiapublishing.com
For customer service and orders:
Toll-Free 1-888-313-2665

Visit us on the Internet at www.arcadiapublishing.com

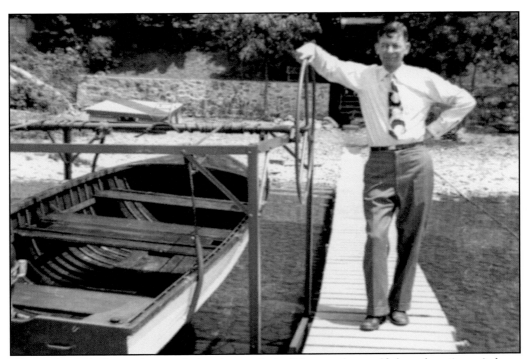

The authors dedicate the work herein to their father and grandfather, longtime Auburn schoolteacher, coach, and founder of Topical Review Book Company, Clarence L. Williams, seen here at his family "camp" along the eastern shores of Owasco Lake in the summer of 1950. The summer home is still enjoyed by the family to this day.

CONTENTS

ACKNOWLEDGMENTS

The authors would like to thank all the friends and family members who helped make this book possible, including Arcadia editor Pam O'Neil. Special thanks go to Louis and Myrtle Chomyk and Peter Bauman for a peek into their outstanding Owasco Lake postcard collections, from which many of the postcards in this publication were taken. Thanks also go to Peter A. Wisbey, executive director, and Jennifer Haines of the historic Seward House for several images that helped to illustrate the rich past and long-gone days on the lake; Gina Stankivitz of the Cayuga Museum of History and Art for a look into its fine collection of Owasco Lake memorabilia; and Gregory J. Alexander for his encouragement, ample refreshment, and editing skills.

INTRODUCTION

Owasco Lake attracted Native Americans and early pioneers for centuries before the lake itself was surrounded by large summer homes coined "camps" beginning in the early 1800s. Its name is thought to have derived from the Mohawk and Iroquois tribes referring to a "crossing," and the lake was a well-known early American encampment. Houses of early settlers began to be constructed on the lakeshore, such as the Throop mansion, which was built as early as 1818. The glory days of the lake came after the Civil War, however, as fortunes accrued during the conflict and the industrial revolution made possible the grand summer homes that once lined its shores in the 1870s.

Auburn, located just two miles from the foot of Owasco Lake, has always had a close relationship with the body of water. Industries, mills, and even the state prison have utilized its outlet for powering machinery. In fact, apparently the idea for a prison surfaced when local leaders lobbied for it after a prisoner of war camp was built along Owasco Lake for British soldiers during the War of 1812. The lobbying worked, and the Auburn Prison ended up the second prison in the state system, preceding even the more well known Sing Sing Prison.

Outdoor recreation and a desire to escape hot city centers led to tremendously popular canoe-rowing races and sailing regattas on the lake in the 1870s and 1880s. Guest and early tourists seeking relaxation often traveled the lake by steamboat or down its shores via railroad to stay at a private house or elegant hotel.

Being on Owasco Lake today, one can begin to find clues of the area's past: an old house tucked into a modern lakefront community and the flat railroad bed of the train that once ran down its western shore. These clues have led the authors to research the names and sites that have long been a part of Owasco Lake history and to present them here, utilizing postcards that proved such a popular method of correspondence long ago. While much of the lake's history is presented here for the first time, it must be understood that an area with such a rich cultural and architectural past is likely never completely uncovered by one publication.

Chapter 1 provides images from two of the lake's amusement parks once located on the northern shores along the Owasco Lake outlet. Begun in 1889 and lasting until 1967, the parks provided countless hours of enjoyment for Auburnians and visitors alike, arriving by train or automobile to enjoy picnicking, moonlit dances, carousel and roller coaster rides, boating, and myriad thrills on the ever-changing amusement rides.

Chapter 2 highlights the very early past of the Owasco Lake outlet, beginning in the 1840s, when it was thought to hold potential to connect to the Erie Canal, a vital transportation link.

The outlet was used by steamships both large and small, private and public, to transport residents and visitors alike to points south along the lake. It was eventually lined with industrial mills and recreational boathouses and served as the split between the two popular amusement parks at the lake's northernmost shore.

Chapter 3 reveals the little-known hotels and resorts that once surrounded Owasco Lake, receiving guests as early as 1870 from steamships and the railroad; in fact, many had their own excursion boats and railroad stations along the Lehigh Valley line on the west side of the lake. The resorts, such as the Ensenore and Cascade, operated much like all-inclusive resorts of today, offering meals, boating, hiking, and nature trails, and overnight accommodations from a few days to the entire summer season.

Chapter 4 examines the role that the lake itself has served, from early transportation via steamships, whose passengers looked out upon forested shores with little or no development, to the era of increased boating and housing along the water's edge. Owasco Lake also served as the landing site for early aviation attempts in 1911.

Chapter 5 explores the many educational camps and summer religious camps that have lined the shores of Owasco Lake for well over 100 years. Few local residents may be aware of the fuss over rowing that resulted in as many as 20,000 people flocking to the lake in the 1870s to witness just one race. Rowing clubs built summer retreats and clubhouses, while former homes along the lake were transformed into summer camps for boys and girls. Yacht and country clubs also have shared the blue waters of Owasco Lake with summer camps that still exist.

Chapter 6 exposes the many large and luxurious summer camps that began to appear on the lake as early as 1818 when Gov. Enos Throop positioned his family home on what is today's Martin Point. From the wealthy homes of Auburn's millionaires to the summer cottages of the working class, Owasco Lake seems to have housed just about everyone with a desire to enjoy its blue waters.

One

Parks and Amusement

The origins of the two major amusement parks that were once located at the foot of Owasco Lake began with the dredging of the Owasco outlet in 1868. A large flat island was created with the removed soil, and in 1889, Charles Haines built an Owasco Lake Park with a clubhouse, dance pavilion, bandstand, theater, carousel, and boathouse. It was short lived, however, as Haines left town with the first summer profits and a large construction debt.

The Auburn City Railway Company purchased the land opposite Owasco Park in 1891 and built an electric railway that connected its newly formed park to the city of Auburn. The amusement park included natural walkways, a trolley station, and a dance pavilion. In 1899, Michael Carmody purchased the amusement park and reopened it as Island Park, adding a carousel and summer theater in 1904. By 1912, the railway company decided to add amusements to its Lakeside Park and to replace a dance pavilion that had burned in 1913, the same year a figure-eight roller coaster was built. The two parks continued to compete for visitors, each adding newer, faster, and more unusual attractions for the next two decades.

In 1930, the trolley line ceased to operate and Lakeside Park went bankrupt. Fred Emerson from the Dunn and McCarthy Shoe Company purchased the park for $250,000 and renamed it the Enna Jettick Park, after a line of women's shoes that were manufactured in Auburn. The park continued to operate until World War II when it was closed for several years due to rationing. It closed for the last time in 1944, and the land was donated to Cayuga County for use as a natural park and sandy beach. Island Park, on the other hand, went through several different owners throughout the 1930s and 1940s and was renamed Deauville Park in 1947 when 15 new rides were added. However, its use came to an end when, in 1967, Cayuga County condemned the park and razed most of its buildings.

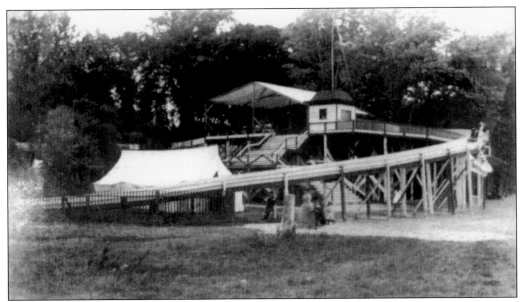

One of the first rides to operate at Lakeside Park on the northern shores of Owasco Lake was this wooden chute. The park itself was owned by Charles Haines, who fled town with large profits after just one year of operation.

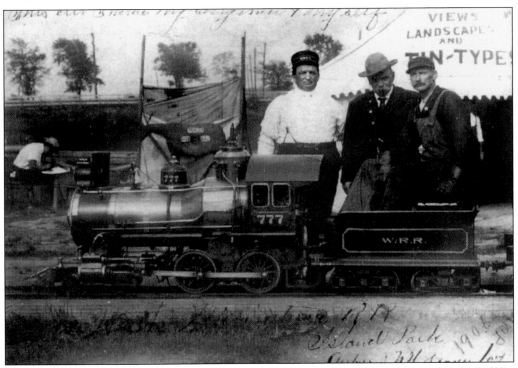

Jack and Billy West purchased this miniature train following its exhibition in 1901 in Buffalo. They installed it in Lakeside Park, to the delight of its passengers, some of whom are seen here in 1906 enjoying its half-mile track. (Courtesy Cayuga Museum.)

The Auburn and Syracuse Electric Railway Company advertised that "all tracks lead to Lakeside Park" in an attempt to draw visitors from as far away as Syracuse and Rochester.

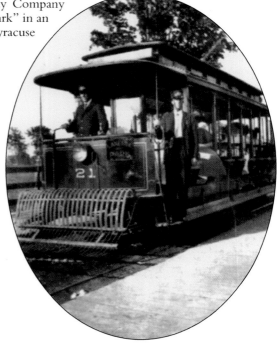

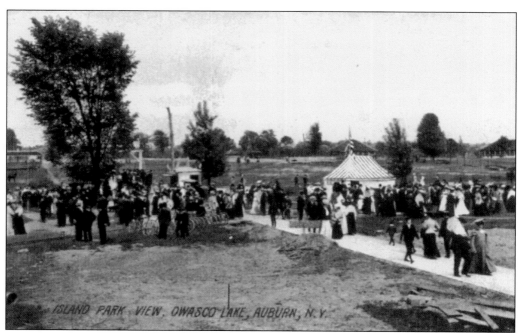

ISLAND PARK VIEW, OWASCO LAKE, AUBURN, N.Y.

Begun in 1889, the early Lakeside Park surroundings were rather sparse and barren, but with a bicycle rental option available, as seen here, one could traverse sidewalks in the cool breeze.

In an attempt to lure potential park goers from as far away as Rochester, the Auburn and Syracuse Electric Railway Company advertised in local papers after they extended their rail system to include Lakeside Park.

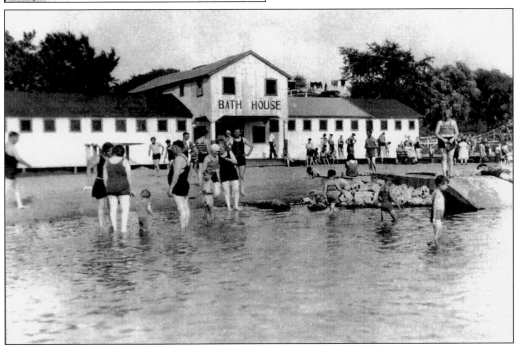

In an era when both men and women sported one-piece bathing suits (*c.* 1920), one of the favorite activities at Lakeside Park was swimming during the summer. (Courtesy Cayuga Museum.)

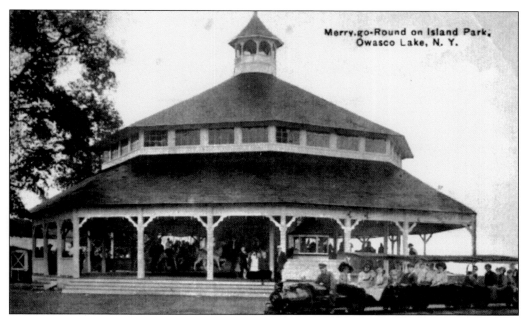

Merry.go-Round on Island Park,
Owasco Lake, N. Y.

In this image taken *c.* 1906, the carousel on Island Park features elaborately carved wooden figures of horses and other animals by craftsman Daniel Muller. It was torn down in 1968. The park itself had been constructed as an extension of Lakeside Park atop reclaimed land that had been dredged out of the outlet.

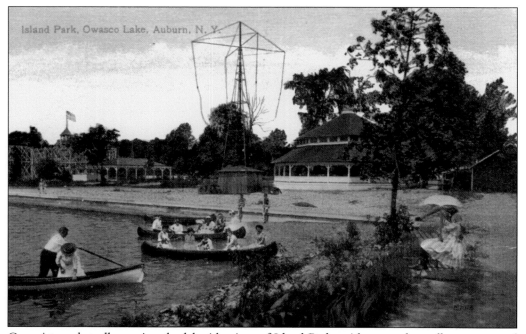

Island Park, Owasco Lake, Auburn, N. Y.

Canoeists and strollers enjoy the lakeside view of Island Park, with a wooden roller coaster and a primitive airplane ride visible in the background. Island Park was created in 1899 when it was owned by William Carmody and attached to Lakeside Park via a small bridge.

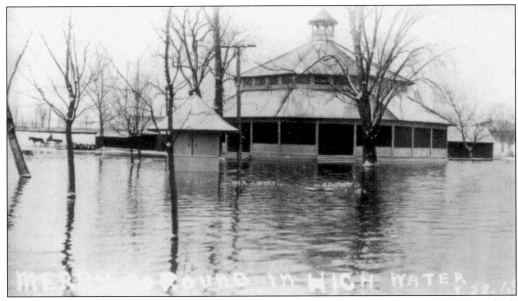

Both Lakeside Park and Island Park were swamped in the famous Auburn flood of 1913, which spelled the demise of many of the older wooden buildings.

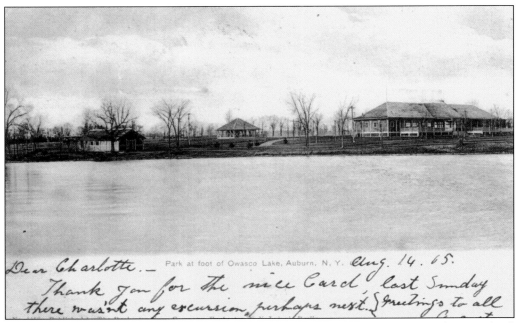

Dear Charlotte. — Park at foot of Owasco Lake, Auburn, N. Y. Aug. 14. 05.
Thank you for the nice Card, last Sunday
there wasn't any excursion, perhaps next. } Greetings to all

This postcard, sent in 1905, expresses regret that there "wasn't any excursion last Sunday," referring to the many steamboats that once traveled between the lakeside parks and points on the lake to the south.

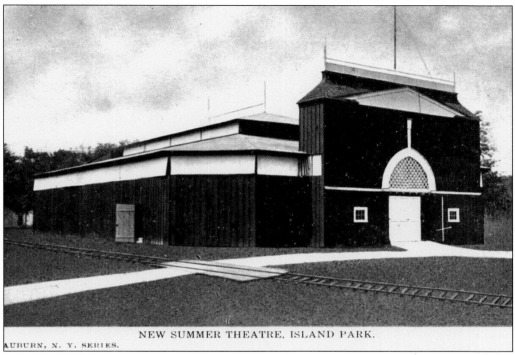

NEW SUMMER THEATRE. ISLAND PARK.

Island Park and Lakeside Park maintained several theaters throughout their long history, entertaining summer residents with plays, musicals, and music performances.

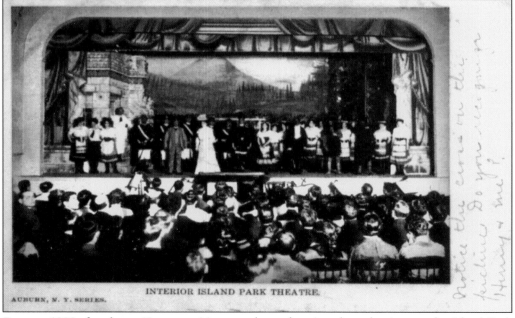

INTERIOR ISLAND PARK THEATRE.

From *c.* 1900, for about 60 years, visitors to the park enjoyed productions at the Island Park Theatre, shown here, and can still enjoy summer stock theater at the well-known Merry-Go-Round Playhouse at Emerson Park.

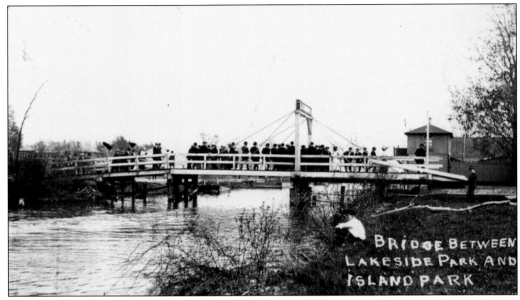

William Carmody purchased the recently formed island to the west of Lakeside Park in 1899 and built this lift bridge to connect Lakeside to his Island Park amusement center, which eventually surpassed Lakeside Park in popularity.

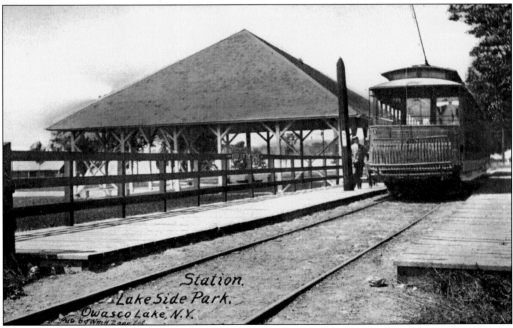

The Auburn and Syracuse Electric Railway built this large covered station at Lakeside Park to shelter its many passengers arriving and departing the park day and night.

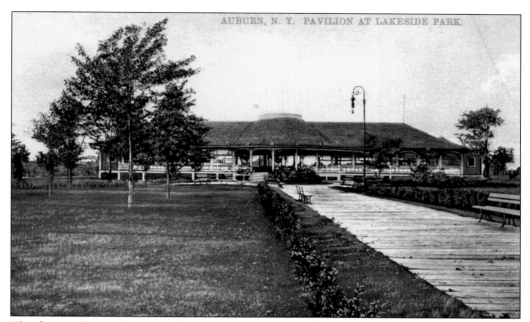

The first pavilion at Lakeside Park was an open-air building that was built in the 1890s, with ornate latticework and leaded windows.

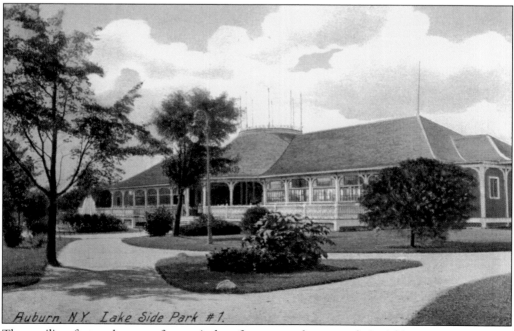

The pavilion featured an area for musical performances, dances, and picnicking.

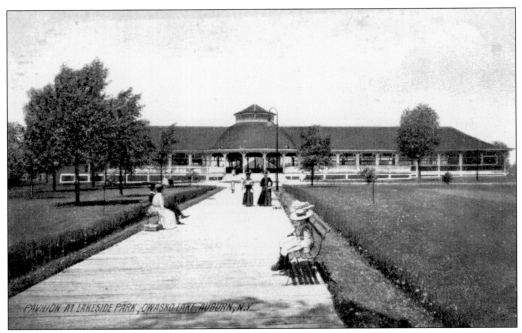

The first pavilion at Lakeside Park underwent several additions and alterations, such as the domed hall in the center, until it burned in 1913 and was replaced by a pavilion that remains at the site to this day.

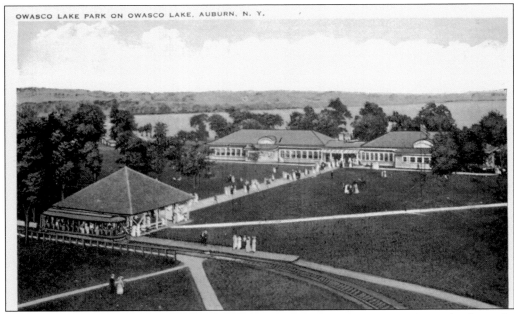

The newly completed replacement pavilion, partially enclosed, was located not far from the trolley line, which carried passengers to and from Auburn. The pavilion remains in use today for musical concerts, weddings, and family picnics.

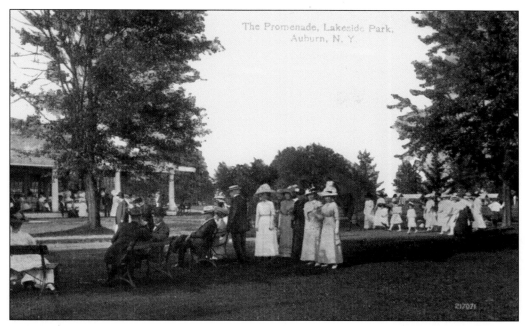

Despite the summer season, these ladies and gentlemen dressed rather formally for a stroll along the water's edge.

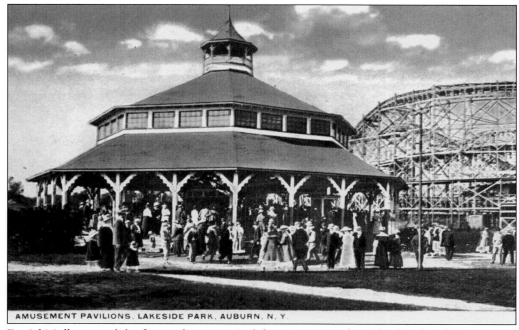

AMUSEMENT PAVILIONS, LAKESIDE PARK, AUBURN, N. Y.

Daniel Muller carved the figures that comprised the main carousel on Island Park, which was used until the 1920s. The building later served as a roller-skating rink, boxing rink, and penny arcade before it was torn down in 1968.

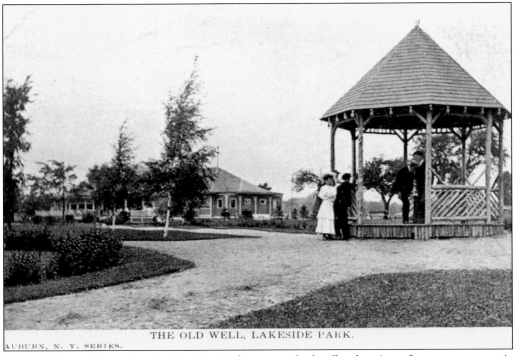

THE OLD WELL, LAKESIDE PARK.

AUBURN, N. Y. SERIES.

The wishing well gazebo at Lakeside Park was undoubtedly the site of many a romantic encounter.

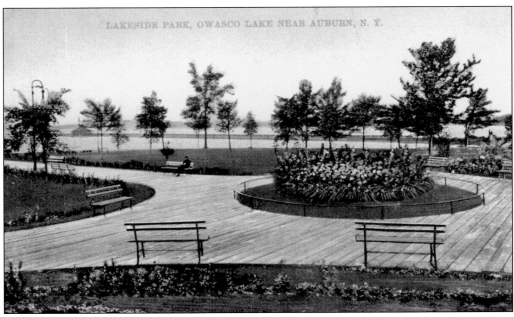

LAKESIDE PARK, OWASCO LAKE NEAR AUBURN, N. Y.

This postcard included a mention of the low lake levels preventing the writer from being able to travel by steamship to one of the resorts on the lake. It was sent in 1908.

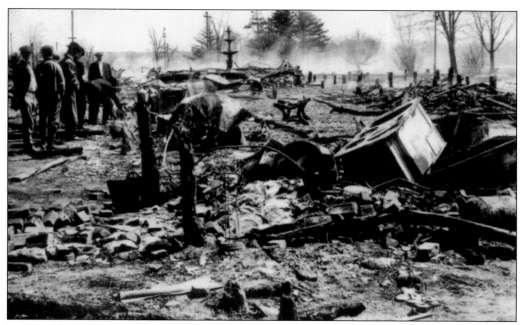

The smoldering rubble from the fire in 1913 that destroyed the original pavilion at Lakeside Park was an attraction in itself.

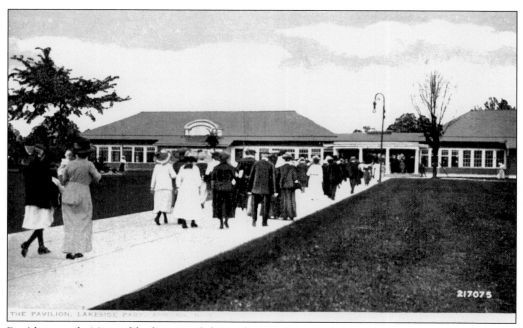

THE PAVILION, LAKESIDE PARK

Residents and visitors alike have used the replacement pavilion continuously since it was built on the same site as its predecessor, which had burned in 1913.

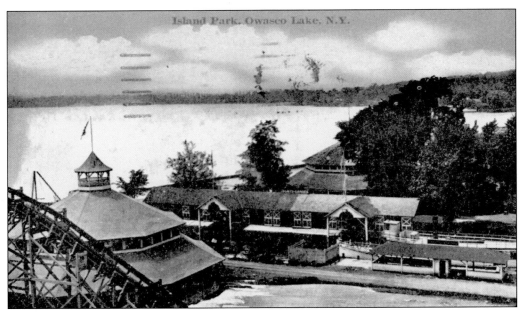

Several attractions can be seen in this postcard of Island Park, including a roller coaster, boat rental, and two carousels.

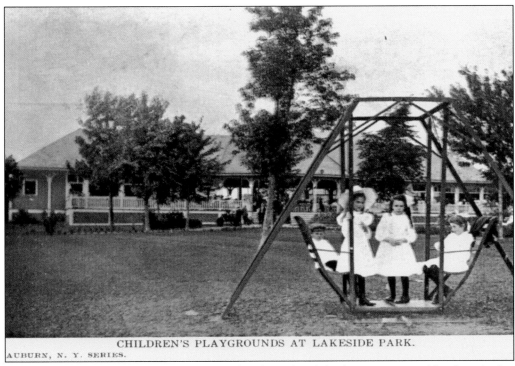

CHILDREN'S PLAYGROUNDS AT LAKESIDE PARK.

AUBURN, N. Y. SERIES.

Even children had their own play area at Lakeside Park, while their parents could enjoy picnics, rides, and even get their photograph taken on a tintype.

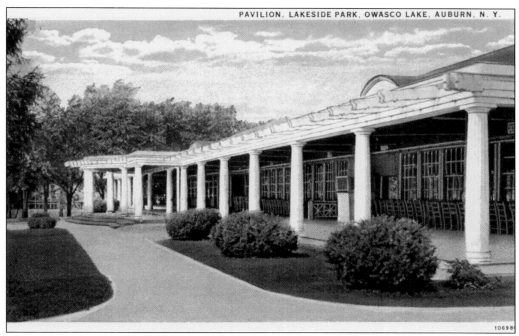

The new pavilion at Lakeside Park featured a wide veranda with outstanding views of the water.

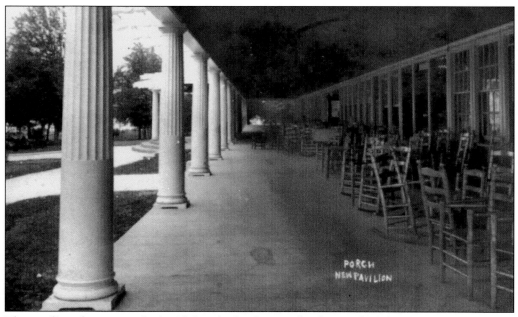

The pavilion also was stocked with hundreds of Mottville chairs, which had been made close-by in the town of Mottville.

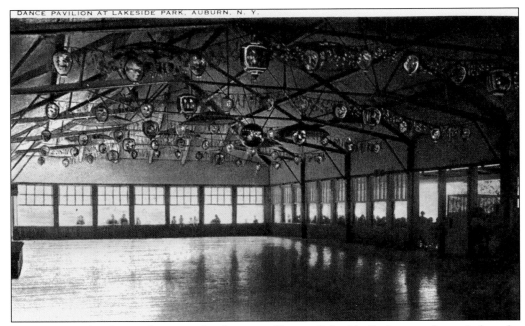

Decorated with Chinese lanterns, the dance pavilion at Lakeside Park was often spied on by onlookers peeking through the windows to catch a glimpse of activities inside.

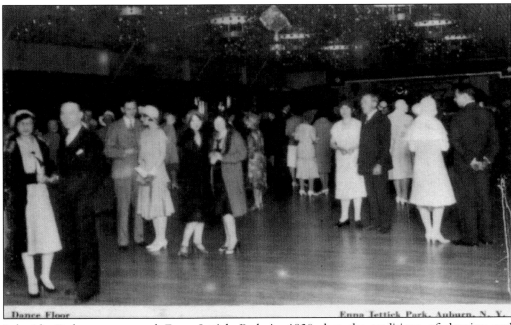

Dance Floor Enna Jettick Park, Auburn, N. Y.

Lakeside Park was renamed Enna Jettick Park in 1930, but the traditions of dancing and entertainment in the main pavilion remain to this day.

24

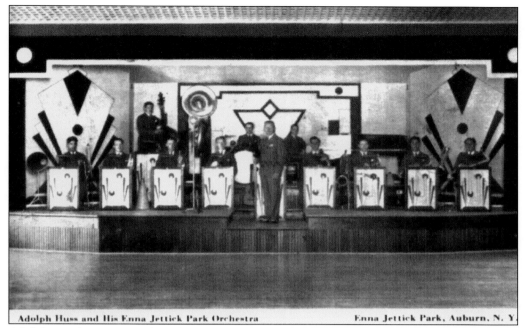

Adolph Huss's Enna Jettick Park Orchestra was one of many bands that played for the various weddings, social gatherings, and dances held in the park on summer evenings.

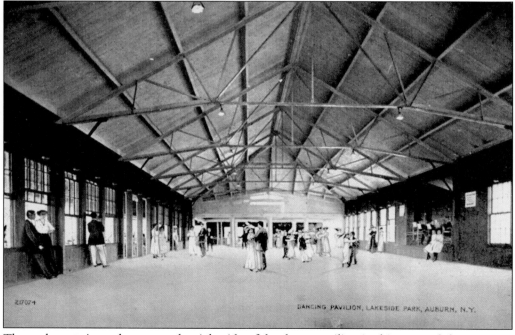

The orchestra pit can be seen at the right side of the dance pavilion in this postcard that was sent to Oswego in 1908.

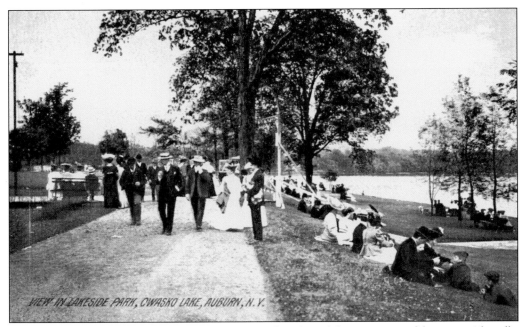

Auburnians and visitors enjoy a lazy afternoon at Lakeside Park by using one of the many sidewalks that were built along the lakeshore.

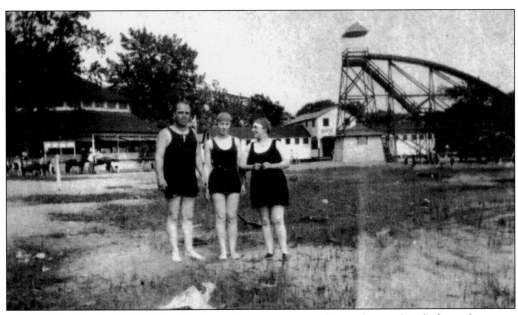

These bathers were captured at Lakeside Park in 1921, perhaps taking a break from the water toboggan ride that can be seen in the background.

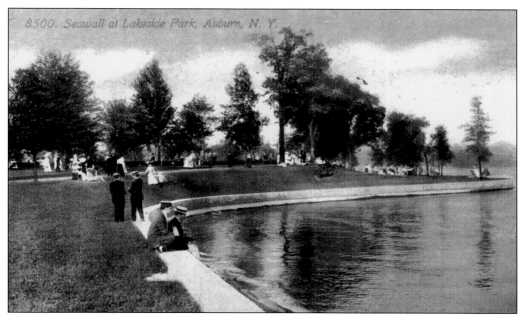

The actual seawall at Lakeside Park no doubt provided much needed relief from hot summers in the city center. It was built in 1905.

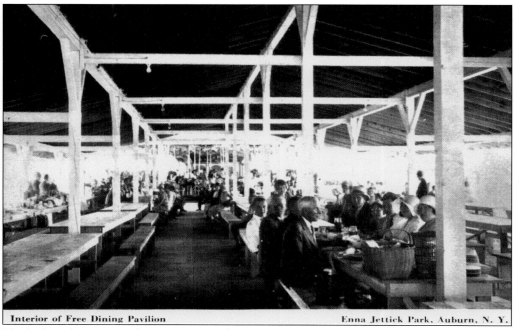

Picnics have been a popular activity since the various pavilions were built at the parks, beginning in 1889.

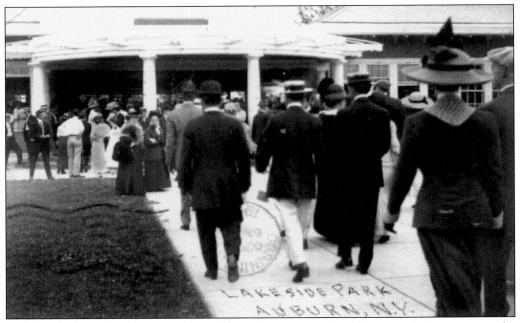

These well-dressed residents are headed into the dance pavilion for one of the many popular dances with live music.

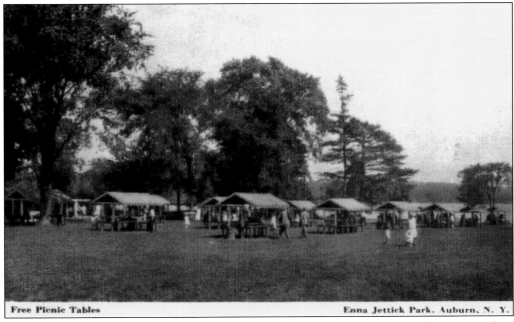

Free Picnic Tables Enna Jettick Park, Auburn, N. Y.

The picnic tables at Enna Jettick Park featured unusual canvas covers for use in inclement weather.

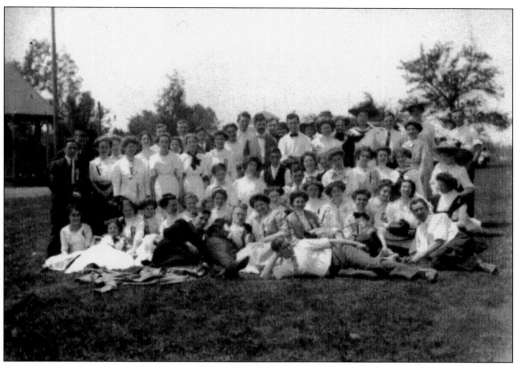

These Baptist church members utilized Lakeside Park for their 1910 summer retreat and meeting.

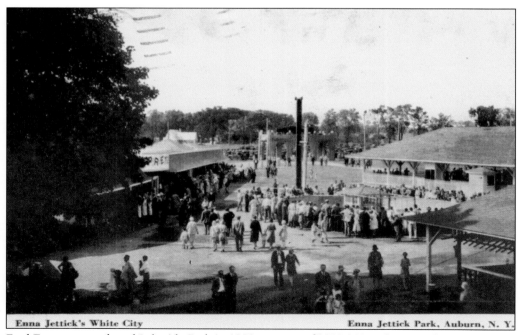

Enna Jettick's White City Enna Jettick Park, Auburn, N. Y.

Fred Emerson purchased Lakeside Park in 1930 at a cost of $250,000 and renamed it Enna Jettick Park after his famous line women's shoes, which were manufactured in Auburn.

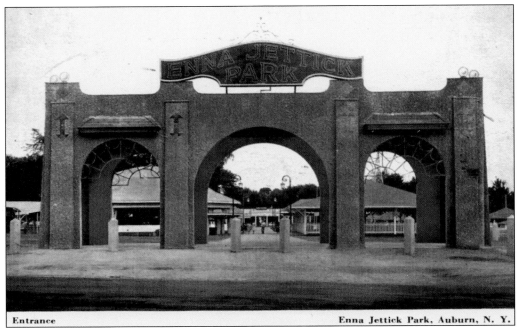

Entrance Enna Jettick Park, Auburn, N. Y.

Enna Jettick Park thrived from 1930 to 1944 when it became a victim of rationing and material recycling for the war effort. It was renamed Emerson Park following Fred Emerson's donation of the land in 1944 to Cayuga County for use as a natural park.

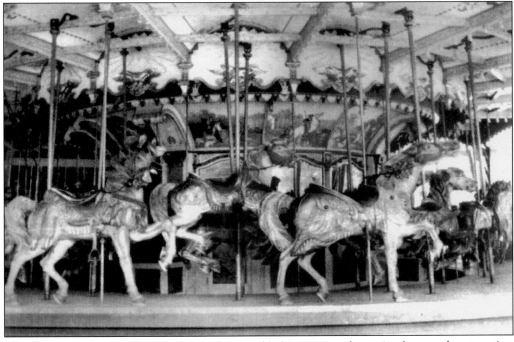

The famous carousel at Enna Jettick Park was added in 1930 and remained a popular attraction until it was sold in 1942 and rebuilt at Hershey Amusement Park in Pennsylvania in 1944.

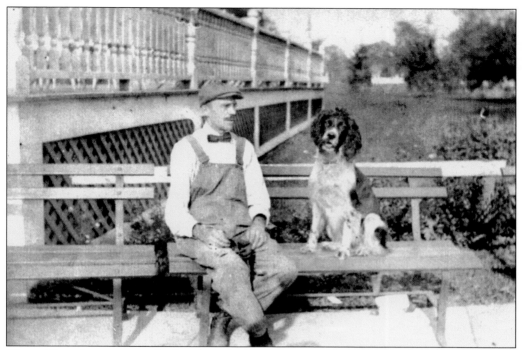

Hiram Titus, the manager of Lakeside Park, poses at the pavilion with his faithful dog.

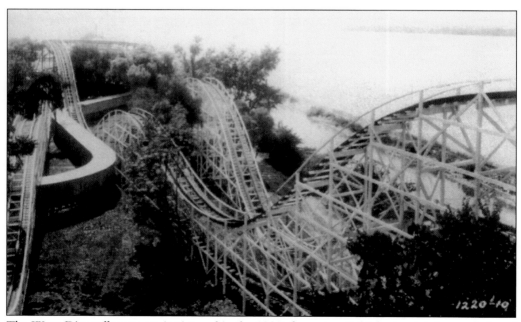

The Waso Dips roller coaster is pictured in the 1920s from atop its highest point. It was designed by John Allen and built by the Philadelphia Toboggan Company in 1921. Note the unique tunnel that thrilled riders in the complete dark.

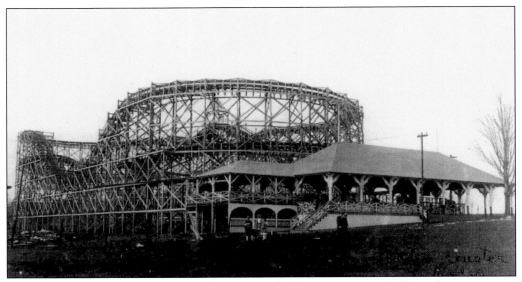

The Figure-Eight roller coaster at Lakeside Park, built in 1916, was the first of many coasters eventually built in the two amusement parks.

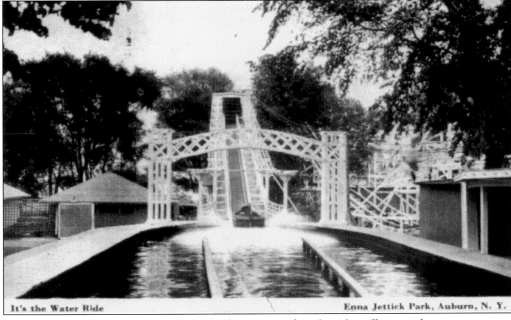

It's the Water Ride Enna Jettick Park, Auburn, N. Y.

The water ride at Enna Jettick Park was the forerunner of similar rides still seen today at amusements parks throughout the country.

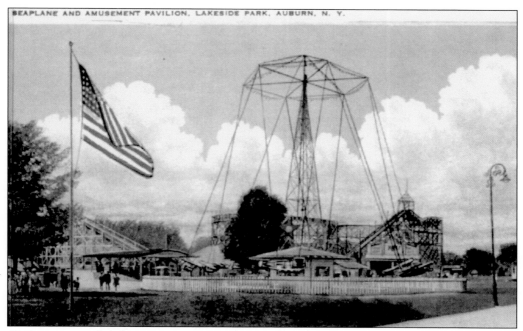

Airplanes suspended from ropes constituted one of the more precarious rides available to Enna Jettick Park goers.

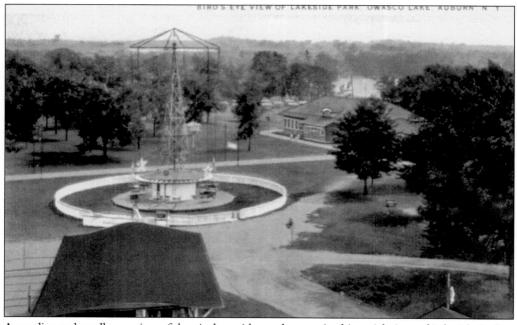

BIRD'S EYE VIEW OF LAKESIDE PARK, OWASCO LAKE, AUBURN, N. Y.

An earlier and smaller version of the airplane ride can be seen in this aerial view of Lakeside Park.

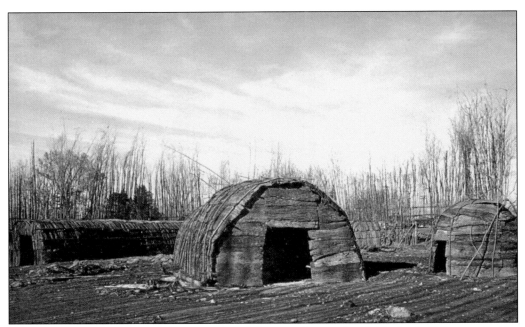

After Lakeside Park became the property of Cayuga County in 1944, the buildings and rides were torn down with the exception of the dance pavilion and the merry-go-round, and this interpretive Cayuga Indian village was built. It was surrounded by a stockade fence and built in a manner in which it was believed the earliest settlers of the area lived and worked. Popular for decades with schoolchildren, the site deteriorated and was torn down in the 1980s.

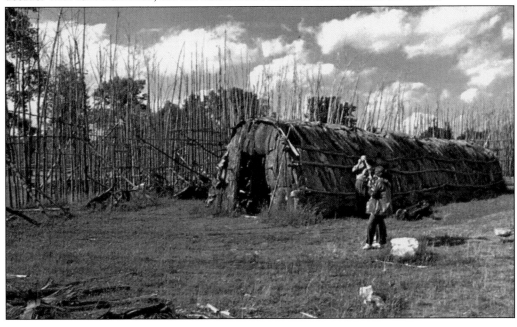

Two

THE INLET
AND THE OUTLET

The Owasco Lake outlet did not always flow north between the familiar piers seen today; instead, it originally snaked through various curves toward its destination in Auburn and points north. With the Erie Canal built following the Seneca River Valley eight miles north of Auburn, area merchants in Auburn and Moravia, located at the head of Owasco Lake, formed the Owasco Lake Navigation Company to link to this important transportation route. The big dam in Auburn was one of several such improvements built along the outlet, in hopes of eventually connecting Owasco Lake with the Erie Canal.

Another such improvement done to the outlet was the dredging and straightening of the small river to better regulate its flow for the myriad mills and the prison shop located on its shores to the north. Begun in the 1840s, it resulted in the creation of an island, which eventually became the site of a hotel and amusement park.

By 1893, the city of Auburn erected a pumping station at the end of a pier at the mouth of the outlet to supply drinking water reservoirs. The Southern Central Railroad followed the shores of Owasco Lake southward beginning in 1869, and numerous prominent Auburnians began to utilize the outlet to launch their private steamboats that carried family and friends to points along the lake to the south or to hotels and resorts on its shore.

The larger steamboats encountered the problem of turning around in the outlet, and an interesting system was engineered just north of Townsend's Dock in which the boats would steer their nose at a large maple tree on the shore, and the boat's crew would hold onto the tree until the back of the boat was turned around with the gentle current of the water.

Both shores of the outlet were eventually the sites of amusement parks, beginning in 1889, and continued to evolve through the creation of various boathouses, repair shops, and recreational businesses renting boats, canoes, and sailboats to visitors and city residents alike, a practice that continues to this day.

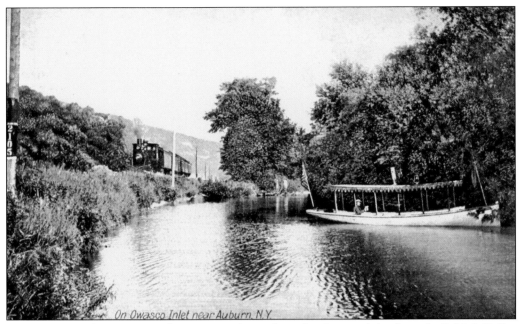

On Owasco Inlet near Auburn, N.Y.

A private steamship witnesses the engine and cars along the Owasco inlet from the Lehigh Valley Railroad, a railroad that ran along most of the western shore of the lake.

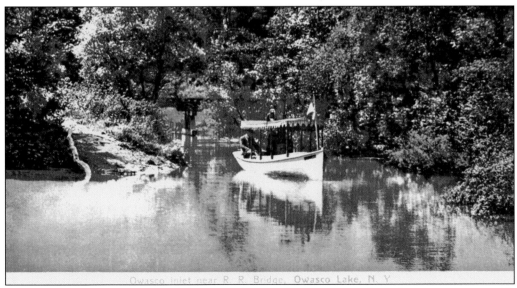

Owasco Inlet near R. R. Bridge, Owasco Lake, N. Y.

The early outlet was traversed by steamships and was apparently rather overgrown with immense vegetation.

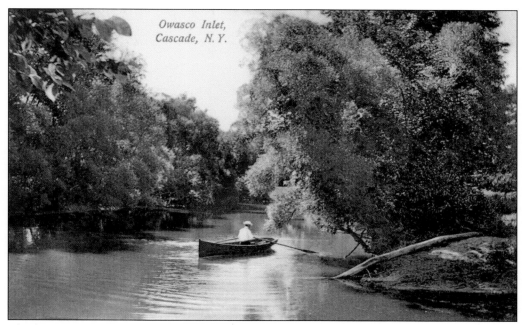

This lone oarsman enjoys the natural setting of the inlet on a summer day.

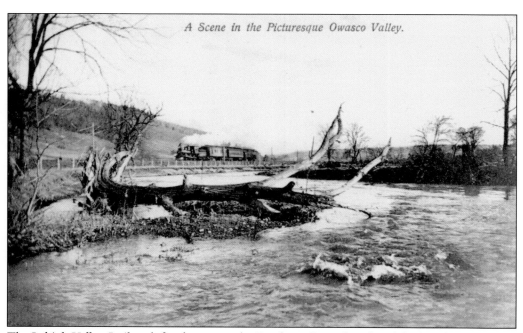

The Lehigh Valley Railroad, first known as the Southern Central Railroad, laid tracks most of the way down the western side of Owasco Lake in 1869. The line was for both excursion trains and the transportation of coal from Sayre, Pennsylvania.

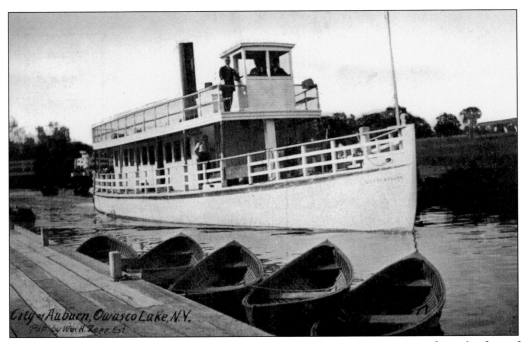

August Koenig, a former mayor of Auburn, used a steamship to run passengers from the foot of the lake to a hotel he had erected on Conklin's Point.

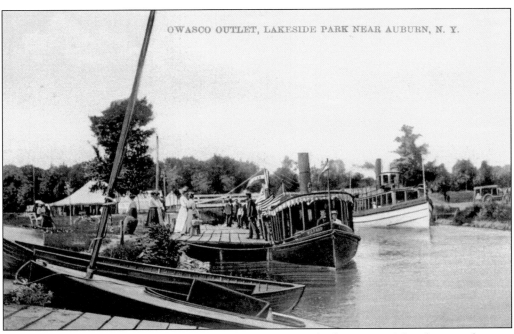

The outlet was used as the port for a variety of steamboats, both commercial and personal.

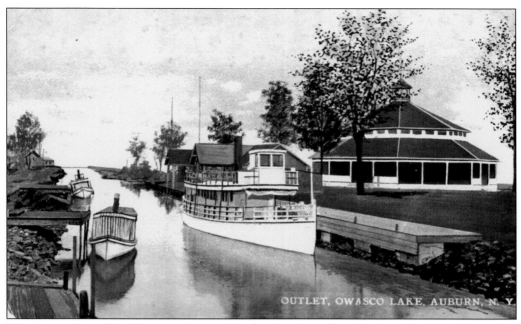

The carousel on Island Park and steamships large and small can be seen here on the outlet, awaiting passengers on land.

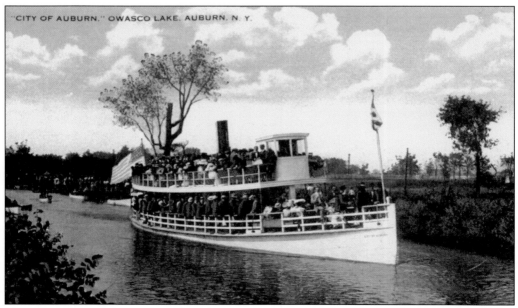

The *City of Auburn* is seen here full of passengers returning from the hotel on Conklin's Point. They would go from the ship to the rail near the outlet to continue their journey.

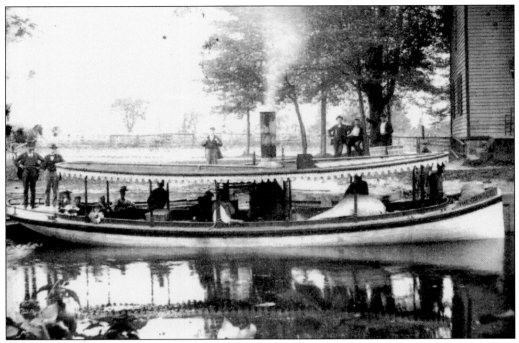

The steamer *Owasco* was one of the first steamers on the lake. It was owned by George Clark, railroad station manager and landlord of the Ensenore Glen Hotel. By 1880, the ship had been renamed the *Ensenore*.

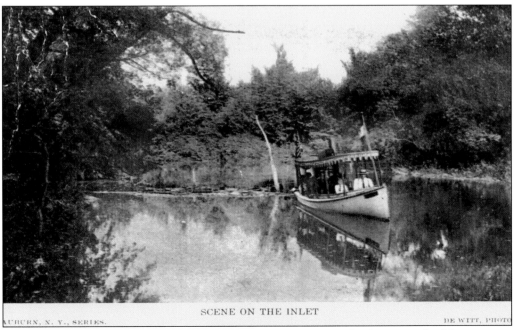

SCENE ON THE INLET

AUBURN, N. Y., SERIES. DE WITT, PHOTO

With its passengers protected by striped canvas, one of the smaller boats on the lake traverses the outlet.

Two small steamers make their way past the amusements and boathouses of Lakeside Park and Island Park.

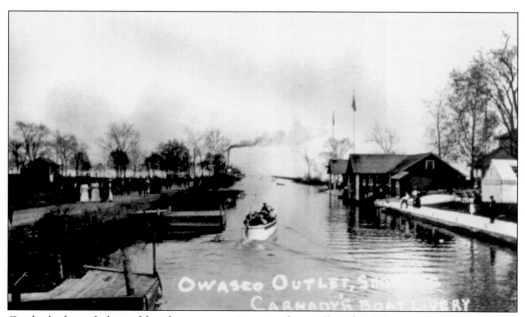

Crude docks and channel boathouses are witness to the small craft, while a large steamer belches smoke at the end of the outlet.

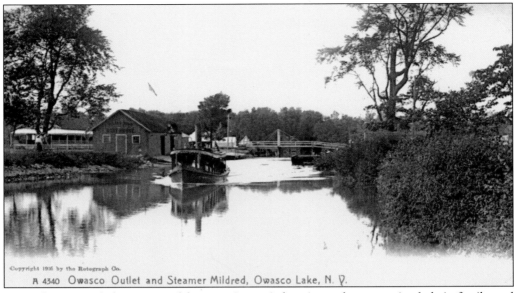

Copyright 1906 by the Rotograph Co.

A 4340 Owasco Outlet and Steamer Mildred, Owasco Lake, N. Y.

One of many such boats owned by prominent Auburnians who entertained their family and friends, the steamer *Mildred* makes its way down the outlet.

TIME TABLE
STEAMER "NEW METEOR"
Beginning July 1, 1907
Owasco Lake.

9:40 BOAT CARRIES FREIGHT AND SUPPLIES.

HOURLY TRIPS 3:00 and 4:00 P. M.

Leave Lakeside Park........ 6:00 A. M.*
Arrive at Wyckoffs..... 6:30 "
Leave Elmwood (Stupp's) 6:45 "
 " Long Point..............7:00 "
 " Conklin's.....7:10 "
 " Union Dock..............7:20 "
Arrive at Lakeside Park....7:35 "

*Daily except Sundays,

Leaves for Wyckoffs, Elmwood, Long Point and Conklin's at 9:40 A. M. 1:20 and 5:40 P. M., returning at 11:30 A. M., 2:45 and 7:45 P. M.

STOP FOR SIGNALS ONLY. White Flag with Red Cross from corner to corner for daytime. Red Light at night. Signals MUST be displayed 15 MINUTES before arrival of boat, on Pole 10 feet above dock.

Hourly Trips, fare 10 cents, Fare to all landings between Lakeside Park, Long Point and Wyckoffs, 25c. Round trip or one way, tickets good for three days only.

Goldsborough C. Smith, Captain.

AUBURN, N. Y.

This timetable from the steamer *New Meteor* was published in 1907 and indicated that a round-trip from the outlet to points about a third of the way down the lake and back was accomplished in approximately an hour and a half.

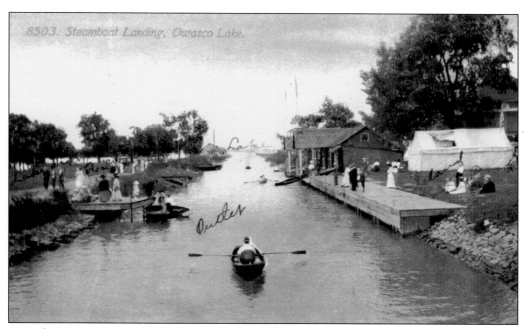

An early rowing canoe with a cane seat is pictured here traversing the outlet.

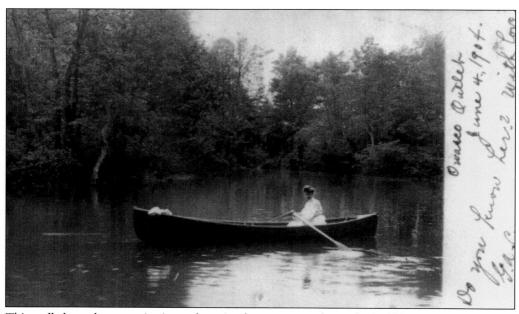

This well-dressed woman is pictured rowing her canoe on the outlet in 1904.

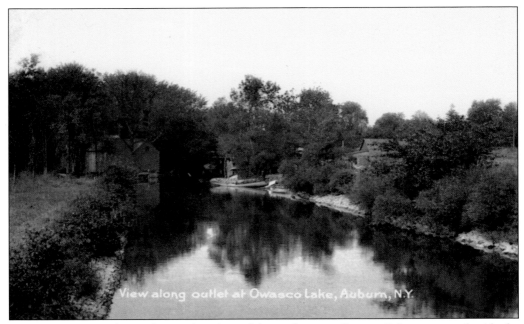

The relative tranquility and natural setting of the outlet near Owasco Lake contrasted with the highly developed and industrial nature of the outlet in the city of Auburn, two miles to the north.

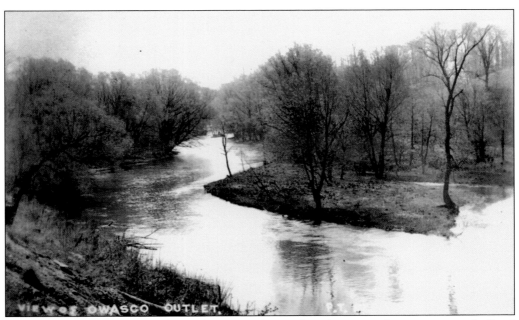

This early view of the outlet shows the untamed natural environment that was soon to be lined with boathouses, mills, and recreational activities.

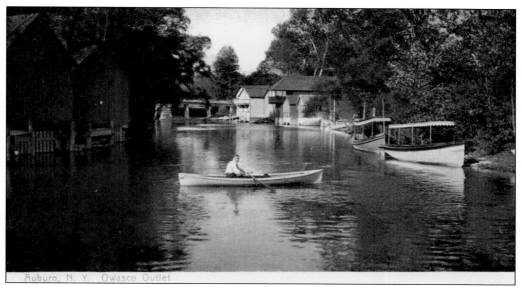

A lone man rows a canoe among the boathouses of various private properties located on the outlet not far from Owasco Lake.

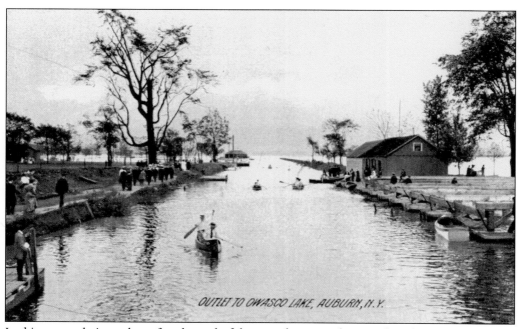

In this postcard view taken after the end of the steamboat era, the steamboat landing can be seen at the right in a state of deconstruction.

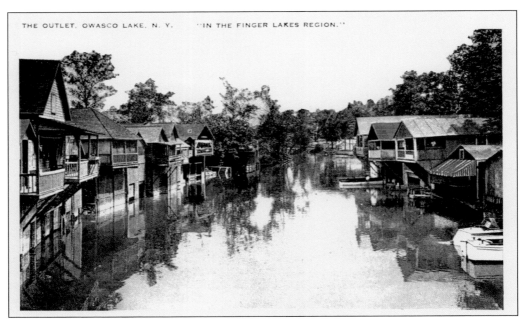

THE OUTLET. OWASCO LAKE. N. Y. "IN THE FINGER LAKES REGION."

As the advent of powered boats descended on the outlet, many more boathouses began to take up space along the shore. Some of them were lived in during the summer months.

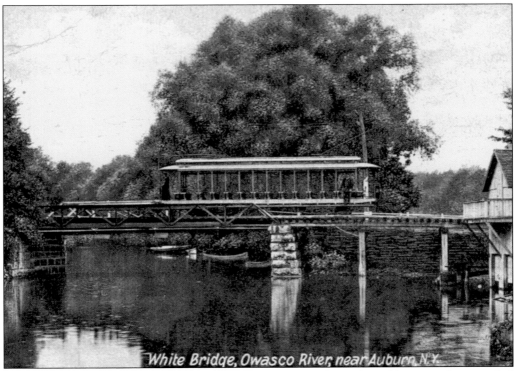

White Bridge, Owasco River, near Auburn N.Y.

An early trolley crosses the White Bridge on the Owasco Lake outlet. This postcard was mailed in 1909.

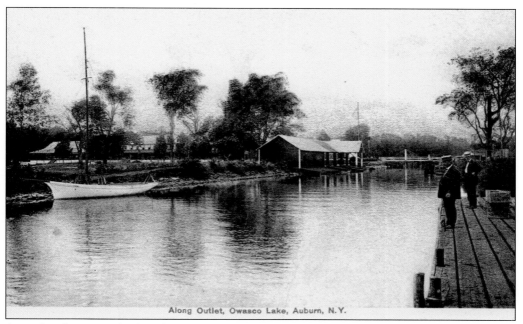

An early schooner is docked along the outlet waterfront, with its passengers perhaps enjoying the amusements then located onshore.

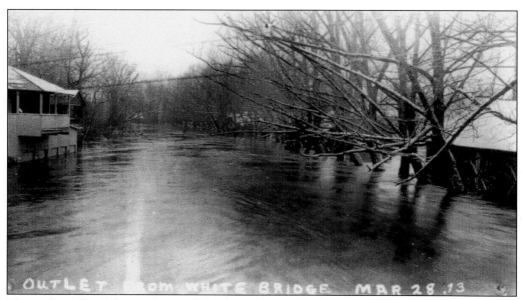

The outlet suffered devastation, as did Auburn, during the flood of 1913.

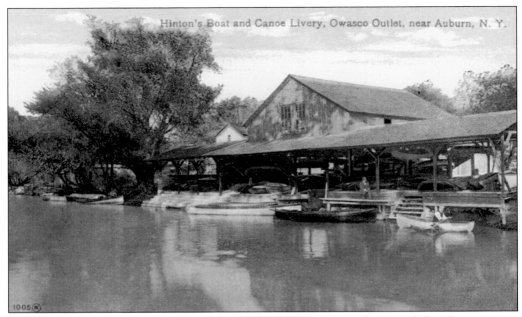

Hinton's Boathouse was a fixture and landmark along the outlet for several decades; remnants of the structure can still be seen along the shore today. The Hinton family had purchased the property along the outlet in 1889.

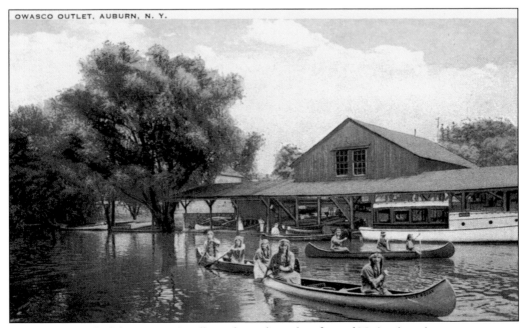

A young women's club met occasionally on the outlet and performed Native American reenactments, seen here; the women are paddling the canoe *White Squaw* past Hinton's Boathouse.

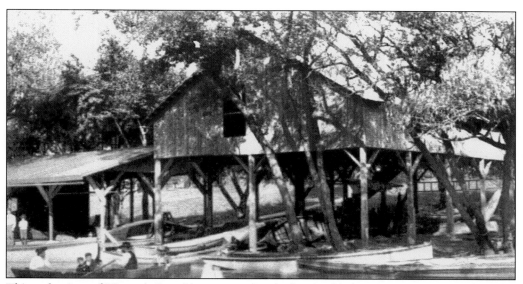

This early view of Hinton's Boat Livery was taken before it added an extensive covered boat slip along the shore. Ed Hinton ran the boat livery and was always on hand to assist boaters in need.

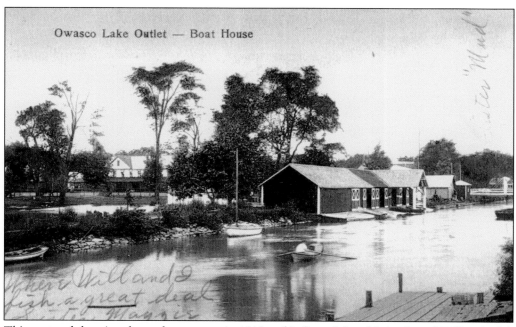

This postcard showing the outlet was sent in 1910 and indicated that this is where "Will and I fish a great deal." The Island Hotel can be seen at the left on Island Park.

The outlet wall virtually disappeared during the great flood of 1913.

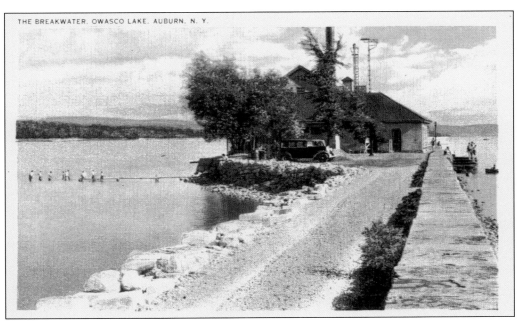

The pump house and breakwater are pictured at a time when the building sported an elegant clay tile roof. The pier and immediate area were recently reworked to include a pedestrian walkway.

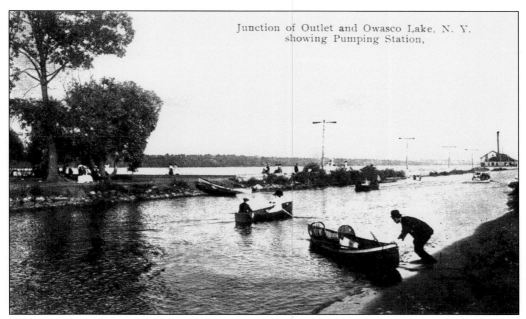

Junction of Outlet and Owasco Lake, N. Y. showing Pumping Station,

This man was photographed launching an elegant canoe with two wooden seats, perhaps in pursuit of the interesting woman who just passed by him.

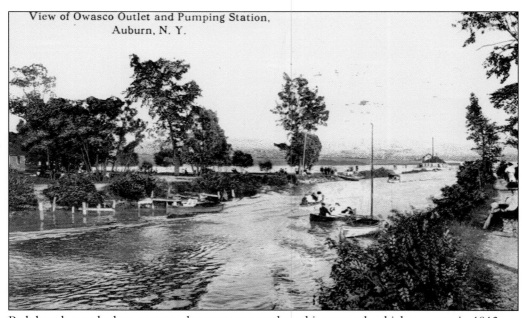

View of Owasco Outlet and Pumping Station, Auburn, N. Y.

Park benches and a lazy summer day were captured on this postcard, which was sent in 1913.

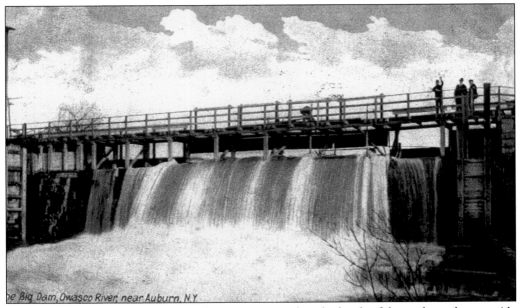

The Big Dam in Auburn was first built in 1835 to regulate the levels of the outlet and to provide waterpower for the mills and prison shop located along the Auburn shores.

Severe winters are not uncommon in Auburn. One such season provided the conditions necessary to completely freeze the outlet over the big dam.

Three

HOTELS AND RESORTS

Following the Civil War, many hotels were located along the shores of Owasco Lake far from the populated northern edges of the lake itself. They were developed and reached by steamships, owned and operated by the hotel owners themselves and used to transport guests to distant shores for recreation and relaxation in the summer months. Most of the hotels were located along Owasco Lake's western shores so that they could also benefit from developing their own railroad stops along the Lehigh Valley and Southern Central rail lines, which had been in operation for both passengers and cargo since 1869.

In a few instances, steamships could not operate from points along the Owasco outlet due to low lake levels, and guests had no other choice than to travel to the hotel via rail or smaller, private steamships that operated on the lake.

Hotels on the shores of Owasco Lake varied from the resort-like complexes that functioned much like self-sufficient resorts of today, complete with their own post offices, train stations, nature trails, boating activities, dance halls, and extended-stay cottages, such as those found at Ensenore Glen Hotel and Cascade Hotel on Owasco. Others were located in closer proximity to Auburn, such as the Springside Inn and the Lakeside Inn, which took advantage of early guests at the twin amusements parks at the foot of the lake.

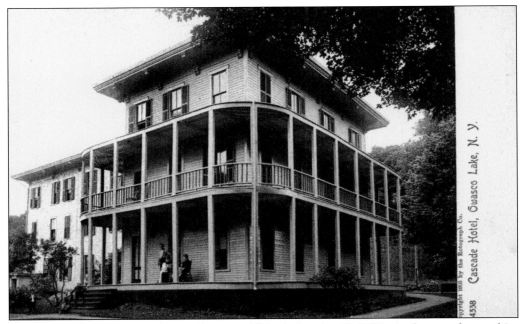

The elegant and large Cascade Hotel was established after the Civil War in the era of steamships and was located at the far south end of Owasco Lake, on its west side.

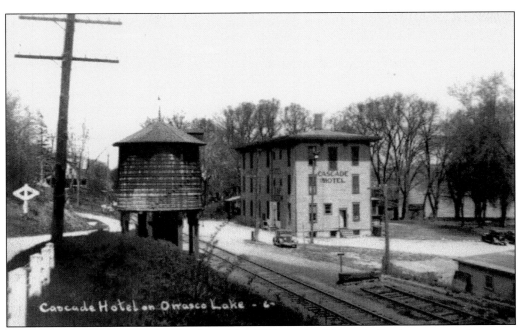

The Cascade Hotel was reached by the Lehigh Valley train. This train line began operating along most of the western shore of Owasco Lake in 1869.

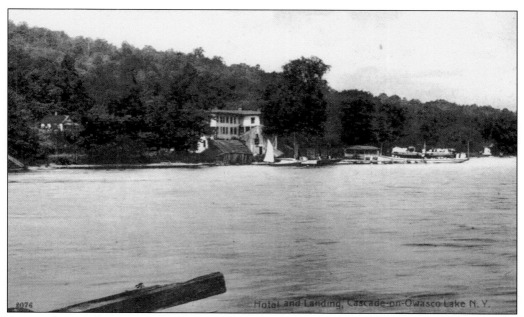

A steamship can be seen at the Cascade Hotel dock, along with several smaller recreational craft utilized by the hotel patrons.

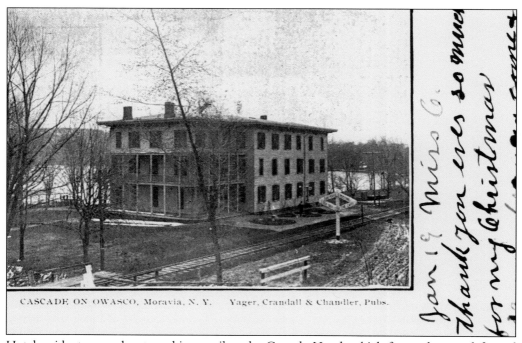

Hotel residents came by steamship or rail to the Cascade Hotel, which featured a wood-framed dance hall, taproom, and wraparound porches facing the lake.

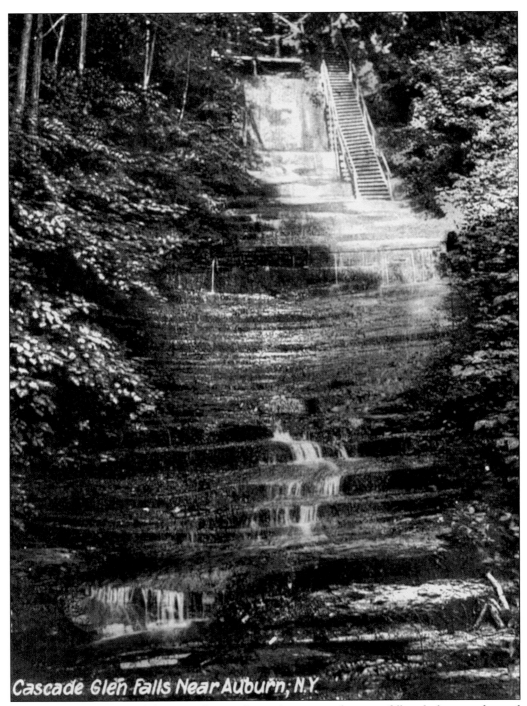

Cascade Glen Falls Near Auburn, N.Y.

One of the attractions of the Cascade Hotel was the spectacular waterfall and glen area located on the resort property, seen here with a wooden staircase to aid in the exploration of the natural wonder. The hotel grounds also featured several private cottages that could be rented for the whole summer.

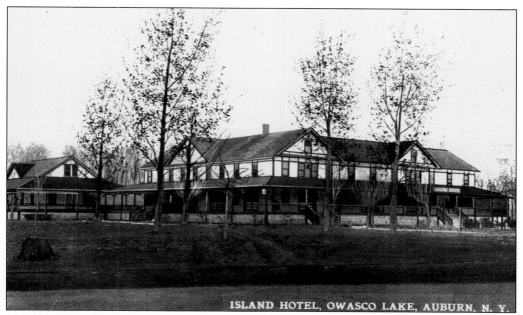

ISLAND HOTEL, OWASCO LAKE, AUBURN. N. Y.

The Island Hotel was built on Owasco Lake's north shore in conjunction with the Island Park amusements *c.* 1899. Patrons reached the hotel via the electric railway from Auburn and were likely to partake in activities at the surrounding parks and beaches.

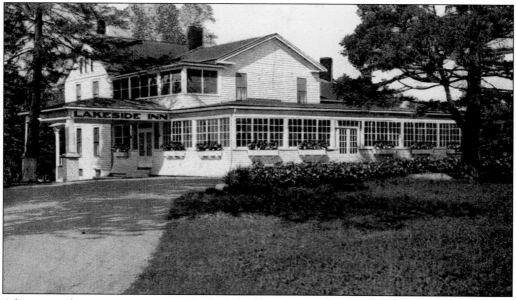

Adjacent to the two amusement parks, the Lakeside Inn was a familiar site along the north shore of Owasco Lake. It was primarily operated as a restaurant but did feature a few rooms for overnight accommodation on its upper levels. It was located next to what is today the Green Shutters restaurant, another longtime fixture, next to Emerson Park.

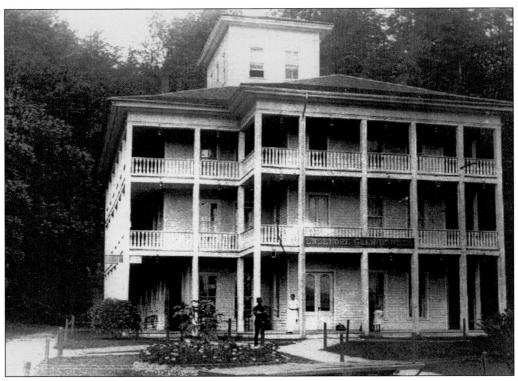

The large Ensenore Glen Hotel was built on the lake's west shore just north of the Cascade Hotel in the 1870s. It, too, was reached by steamship or rail. (Courtesy Cayuga Museum.)

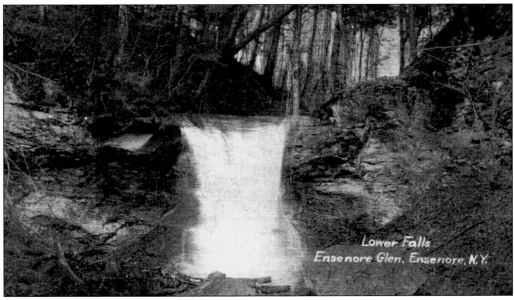

For the delight of its patrons, the Ensenore Glen Hotel featured its own natural wonders, including upper and lower waterfalls.

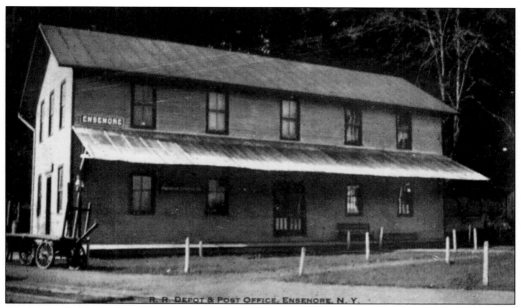

The Ensenore Glen Hotel site operated as a miniature village, complete with its own post office, railroad stop, and several outbuildings.

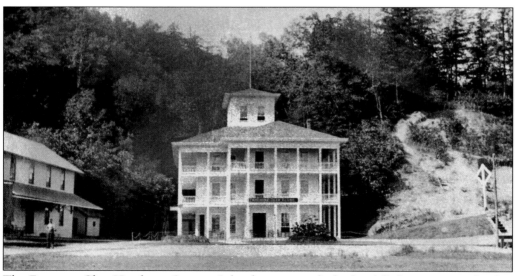

The Ensenore Glen Hotel, on Owasco Lake shores, once had a hand-lit lantern on each of its more than 40 porch openings. On September 27, 1877, more than 20,000 people descended on the Ensenore to watch an epic single sculls race.

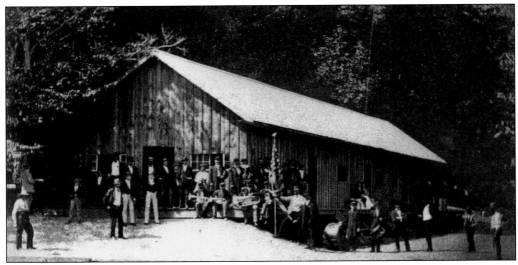

The Ensenore Glen Hotel built this hall *c.* 1870 to house dances and large groups that would come and go via the Southern Central Railroad.

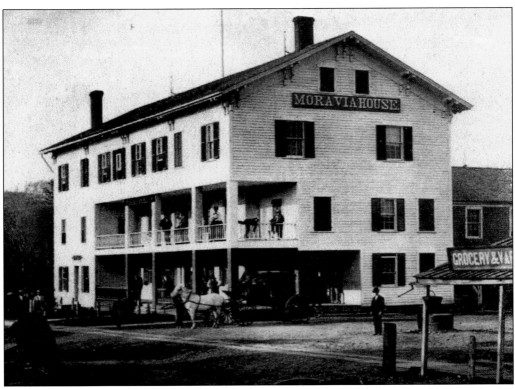

The Moravia House Hotel, along the inlet in Moravia on the southern portion of Owasco Lake, was the site of future president Millard Fillmore's marriage. Fillmore had grown up in a small frame house overlooking the shores of the lake. (Courtesy Cayuga Museum.)

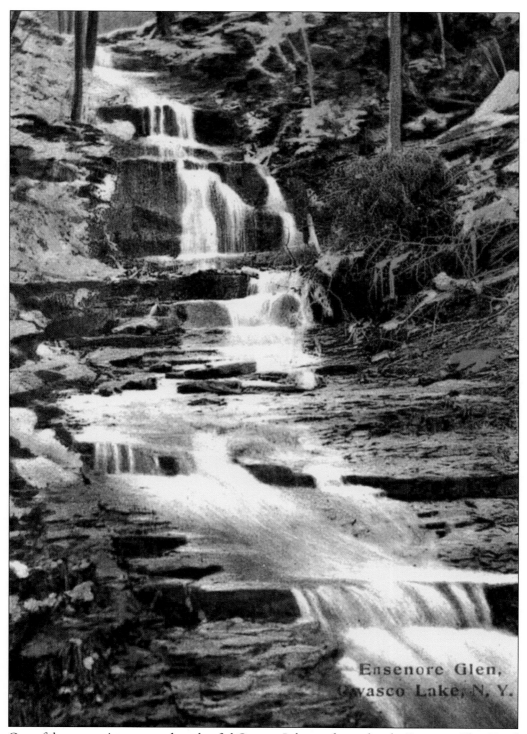

Ensenore Glen,
Owasco Lake, N. Y.

One of the many picturesque glens that fed Owasco Lake was located at the Ensenore Glen Hotel site. Today the glen is heavily vegetated and no longer a tourist destination.

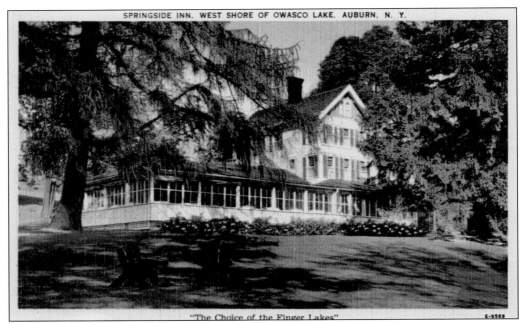

"The Choice of the Finger Lakes"

E-9569

Springside Inn has been a fixture on the north shore of Owasco Lake since 1919, evolving from a private house built *c.* 1859. From that time to the present, the inn has been entertaining and housing thousands upon thousands of visitors and diners.

EMBASSY ROOM

All Auburnians recognize the interior of the Springside Inn, famous locally for its ever popular cheese soufflé, once recommended by Duncan Hines as an "adventure in good eating."

FILL YOUR LUNCH BASKET
and spend a day at
KOENIG'S POINT
In the Cool of the Giant Trees.

Electrically Lighted Throughout.

DANCING AT THE PAVILION.

Swings for the Children
and Tables for Basket Picnics.

THE PUREST OF SPRING WATER.

THE BEST OF TROUT FISHING.

BOAT LIVERY, "CLAXTON."

HOTEL TERMS.

$ 3.00	-	-	-	per day
$14.00 a person,	-	-	-	per week
$12.00 " "	-	(two in one room,)	"	"

TIME TABLE.
STEAMER "CITY OF AUBURN"
Makes Regular Trips to and from the Point
Boat Leaves City of Auburn Dock.

2:00, 3:30, 6:00, 7:30, 9:00

SUNDAYS AND HOLIDAYS.
Boat Leaves City of Auburn Dock.

12:30, 2, 3:30, 5, 6:30, 8, 9 P. M.

(OVER.)

The small hotel at Koenig's Point about a third of the way down the lake on the east side was a popular destination, first reached by the steamship *City of Auburn*.

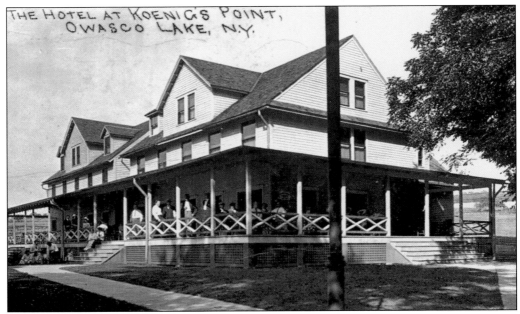

Koenig's Point was named after August Koenig, the owner of the small hotel located on what was previously called Conklin's Point.

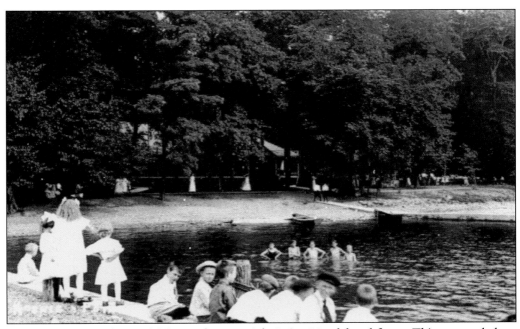

Youngsters enjoy the cool lake at the Koenig's Point Hotel beachfront. This postcard dates from *c.* 1910.

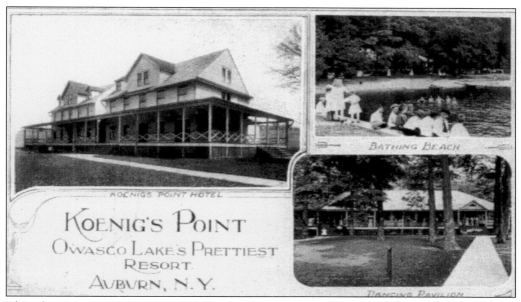

This advertising postcard announced that the Koenig's Point Hotel was "Owasco Lake's Prettiest Resort," featuring a dance pavilion to entertain its guests.

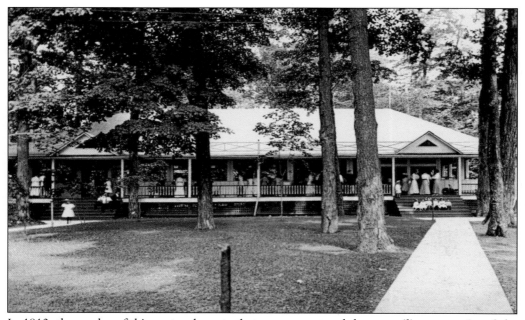

In 1913, the sender of this postcard wrote that a corn roast and dance pavilion was enjoyed the "day after Labor Day" that year.

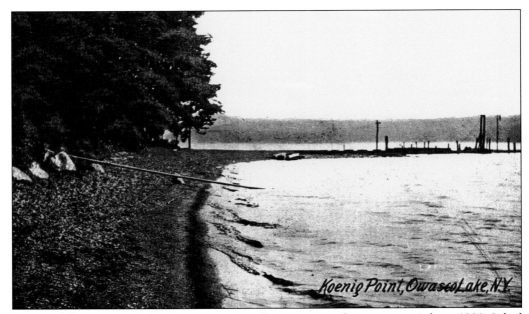

The beachfront at Koenig's Point was typical of many points along Owasco Lake *c.* 1900. It had little development or neighboring houses to interfere with lake activities.

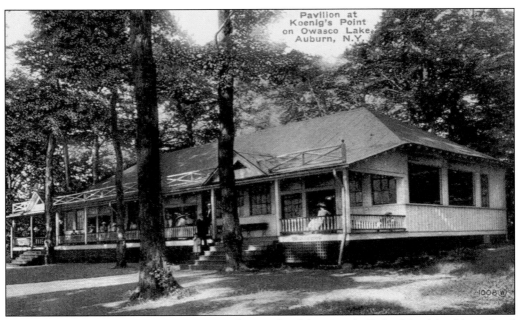

Hotel guests enjoy a peaceful moment on the porch of the Koenig Point Hotel in this undated postcard, which shows the dance pavilion on the property.

Four

Boating and Lake Scenes

Owasco Lake, an ample body of water, has from an early time been witness to various boating activities and recreational uses. Throughout its history, it has been a source of fresh fish for Native American tribes, early settlers, and current residents. The lake also has served as a transportation route, with steamships both privately and publicly owned transporting hotel guests, private parties, and paying passengers. The shores of the lake have been transformed from a rural enclave of heavily treed forests, farms, and pasturelands to a ring of cottages, summer homes, and increasingly large year-round estates.

The very first marine engine produced was tested exclusively in a boat on Owasco Lake near Auburn. In 1901, the Fay and Bowen Boat Company built a line of small motorboats and emphasized the reliability of the engines through a rigorous testing program, which included installation and operation of the marine engine before the boat was shipped to the customer.

Activities on the water itself have gone from simple rowing, paddling, and sailing vessels to large steamships, motorboats, and personal watercraft vehicles that define the lake experience of today. Gone, too, are the train whistles that were a once familiar noise along the western shore, although still evident is the track bed over which more than 100 years of daily coal and passenger transportation passed.

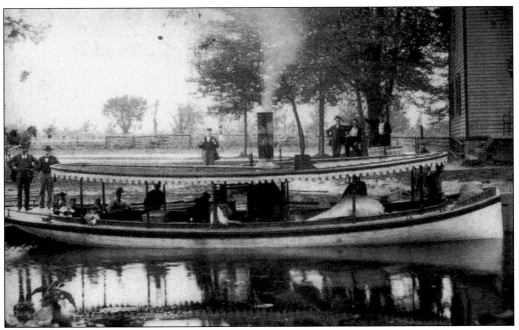

The graceful steamer *Owasco* heads to the Cascade Hotel with elegantly dressed passengers in the 1890s.

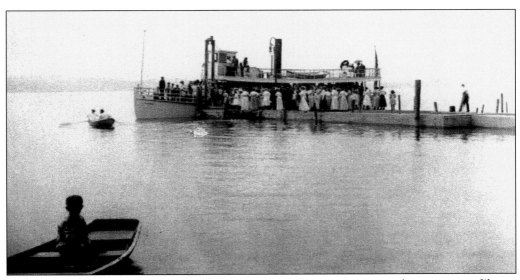

The steamer *City of Auburn* docks near the outlet, waiting to transport what may seem like an extraordinary amount of passengers. It succeeded the *Lady of the Lake* as the largest passenger boat carrying people to and from Conklin's Point.

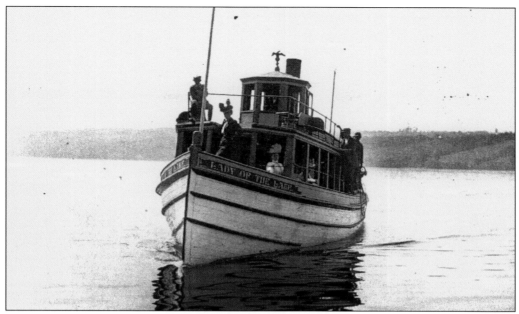

The steamer *Lady of the Lake* transports passengers up and down Owasco lakeshores *c.* 1890. One of its name boards is now located at the Cayuga Museum of History and Art. (Courtesy Cayuga Museum.)

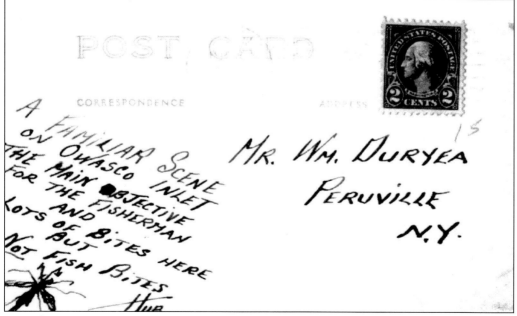

Sent when postage was a mere 2¢, this postcard offered the following advice to potential fishermen and visitors to the lake: "The main objective for the fisherman and lots of bites here, but NOT fish bites."

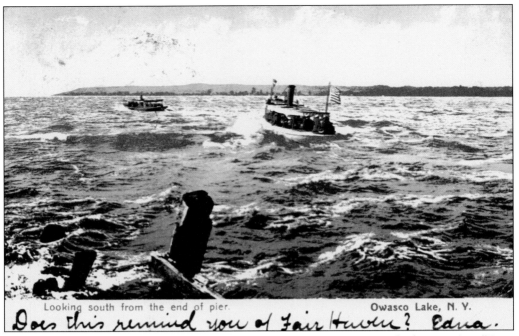

Looking south from the end of pier. Owasco Lake, N. Y.

Does this remind you of Fair Haven? Edna.

This postcard of rough weather on Owasco Lake was sent in 1907 with the notation "Does this remind you of Fair Haven?" referring to a resort hotel on Lake Ontario, apparently also approached during inclement weather.

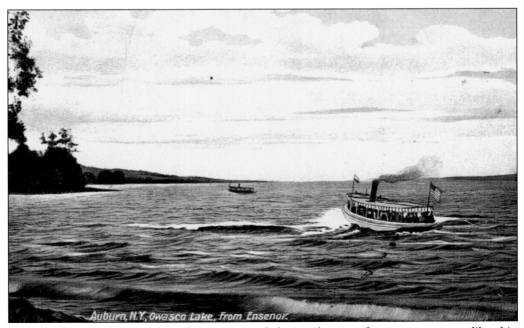

Auburn, N.Y., Owasco Lake, from Ensenor.

One familiar site that may have been witnessed during the era of steamers was one like this, captured on a postcard sent in 1911.

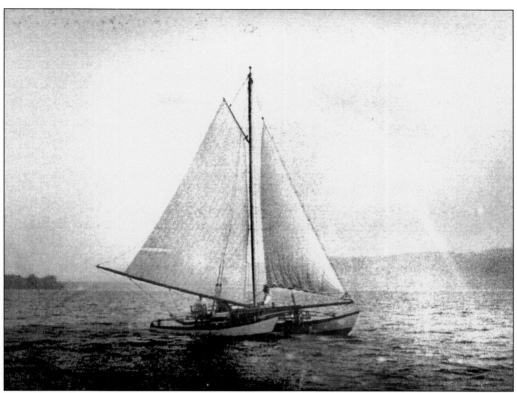

This large and unusual catamaran sailboat was built for Willard Case of Auburn and Owasco Lake at his summer retreat, "Casowasco," in the 1880s. It was a large sloop-rigged craft, with hinged deck beams connecting its narrow twin floats, steered by a twin rudder. It was able to sail the choppiest waters without worry of overturning.

This current picture of Wyckoff Station, along the western shore of Owasco Lake, illustrates the somewhat unusual proximity of the railroad station of the Southern Central Railroad to the actual shores of Owasco Lake and the fact that the station still exists long after the tracks were abandoned in the 1960s.

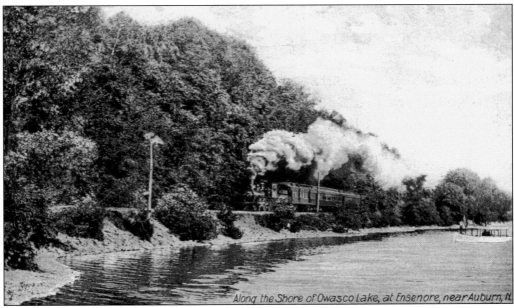

Along the Shore of Owasco Lake, at Ensenore, near Auburn, N.

This image of the railroad thundering down the western side of Owasco Lake adjacent to the lakeshore illustrates what is still evident today if one looks closely at the west shore cottages: a clear rail bed, today often built upon with homes, driveways, and front lawns.

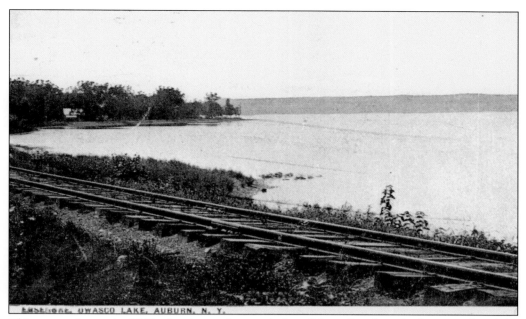

This postcard, sent in 1920, also shows the proximity of the railroad tracks that once lined the western shores of Owasco Lake.

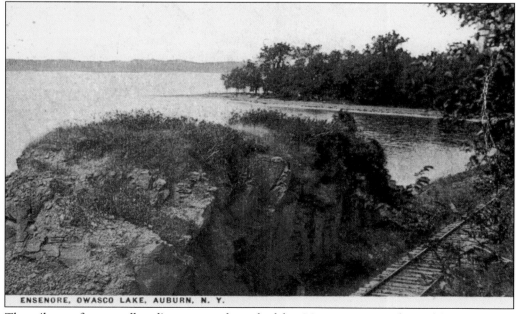

The railway often actually split property along the lake. Many owners are housed in cottages on the upper side of the track and have their beachfront areas below the track.

Greetings from OWASCO LAKE, Auburn, N. Y.

Many of the lakefront properties along the western side of the lake had to accommodate the rail track, seen here to the right.

Owasco Lake "05" Auburn N.Y.

Women of the Victorian period found the waterfront of Owasco Lake an interesting area to stroll, passing the time while awaiting steamships. This view dates from the summer of 1905.

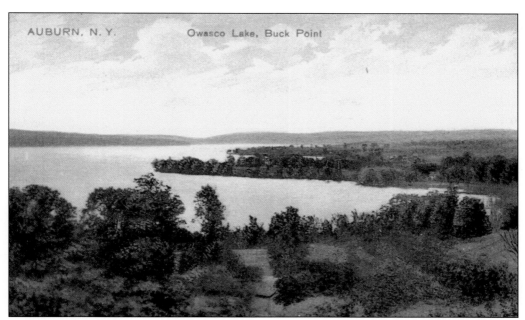

Buck Point, on the west side of the lake at the northern edge, is today full of waterfront homes and a planned community, a vast contrast to the image here of farmlands and wilderness.

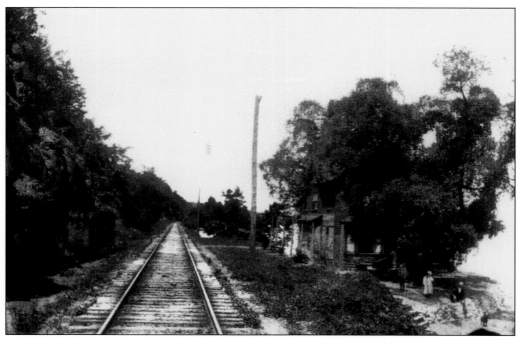

The residents of this summer dwelling had to deal with several trains per day passing close to their house, which was located between the tracks and the shores of Owasco Lake. Although some residents might have considered this unfortunate, train-loving residents probably were delighted. (Courtesy Cayuga Museum.)

This *c.* 1870 home once belonged to E.C. Burtis. It was once located on the southern side of Burtis Point, near a small brook. Burtis maintained an orchard on the lowlands of the point and later even installed a motor speedway, to the delight of many of the area children.

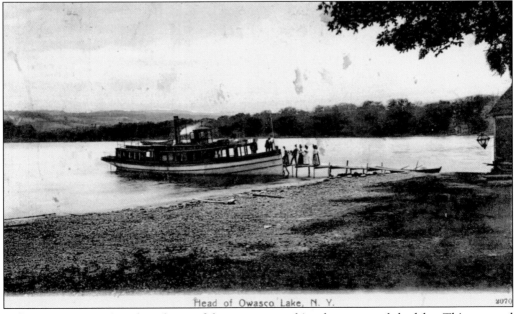

Head of Owasco Lake, N. Y.

A few passengers wait to board one of the many steamships that traversed the lake. This postcard was sent in 1911.

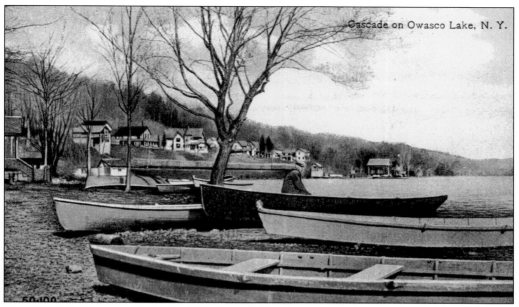

The canoes lined up on the shore of the Cascade Hotel resort area show the many smaller cottages of the community often rented for the summer season.

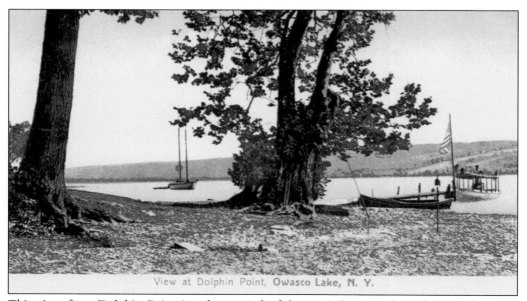

This view from Dolphin Point is rather typical of the myriad points along the lake that once sported homes and camps in a rather natural setting.

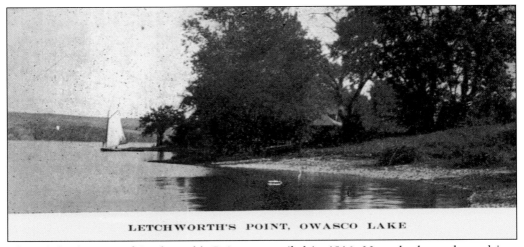

LETCHWORTH'S POINT, OWASCO LAKE

This subdued image of Letchworth's Point was mailed in 1916. Note the house located in a heavily treed area to the right.

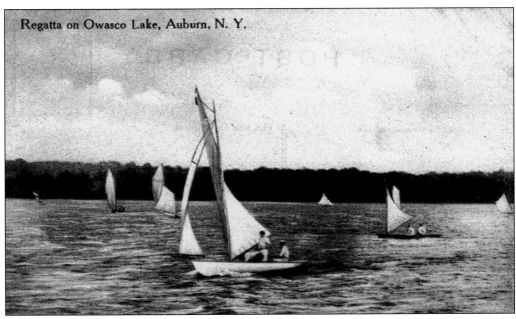

Regatta on Owasco Lake, Auburn, N. Y.

Sailing has always been a popular activity on Owasco Lake, as this postcard of a regatta shows.

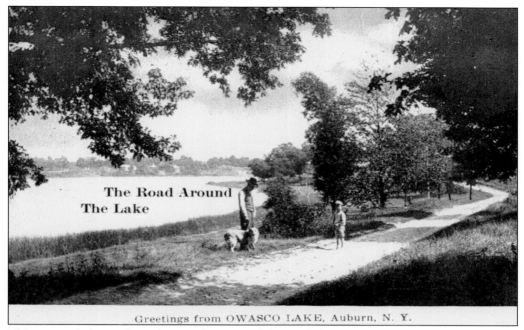

This postcard shows the rather rural nature of the road that surrounded Owasco Lake in the early days.

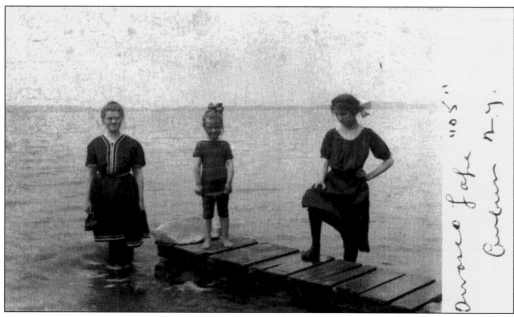

These youngsters on a precarious dock sported the bathing attire of the day. The postcard was sent in 1905.

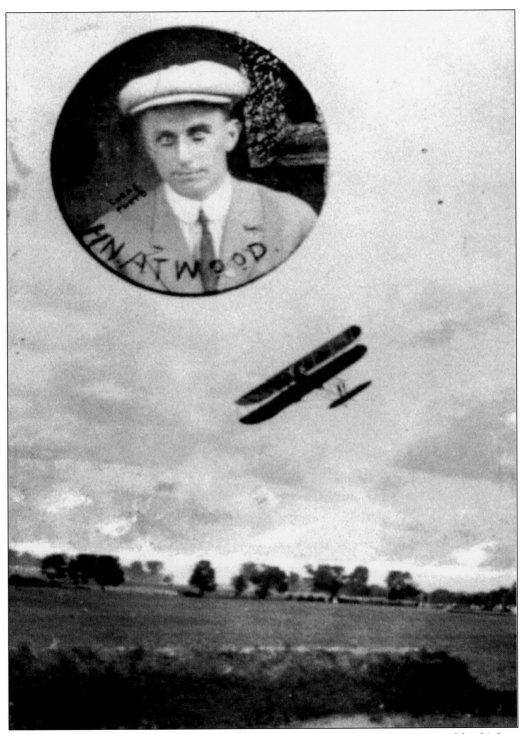

In what was one of the earliest attempts at flying, pilot H.N. Atwood demonstrated his biplane over the waters of Owasco Lake in August 1911.

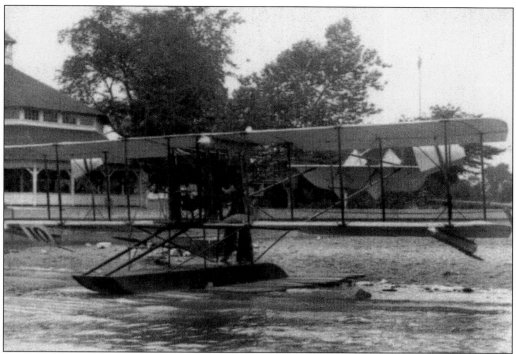

H.N. Atwood's biplane was pictured in the Owasco Lake outlet with the carousel building in the background. The plane was fitted with a special float that enabled it to traverse water.

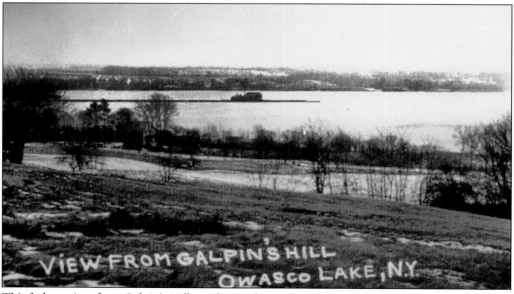

This forlorn view from Galpin's Hill, on the northern edge of Owasco Lake, shows the outlet piers and the Auburn Water supply pump house, long before the area was developed with houses.

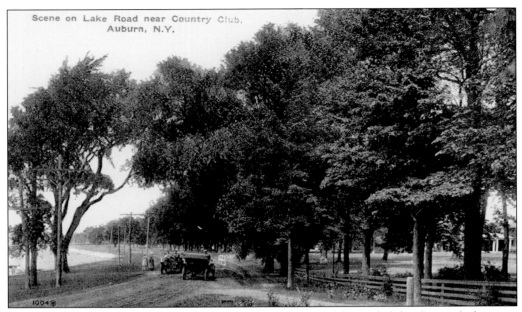

What is today a familiar scene is pictured at a time when Model Ts ruled the dirt road: the town of Owasco, in front of the Owasco Country Club.

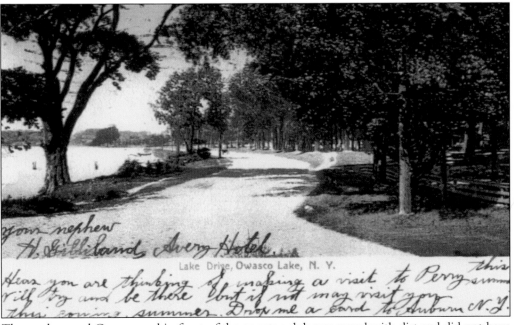

The road around Owasco and in front of the country club was paved with dirt and did not have the highway safety features seen on the road today.

This idyllic drive along the shores of Owasco Lake illustrates the rural and natural surroundings of the area, highlighted by picket fences and dirt roads.

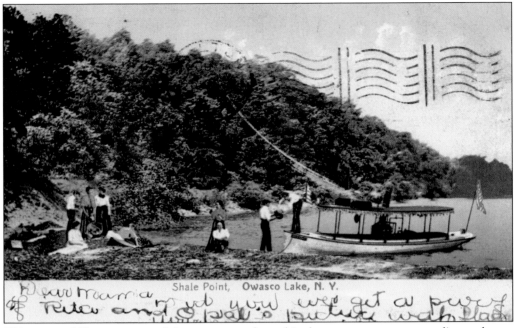

Shale Point, Owasco Lake, N. Y.

This postcard illustrates one of the many steamboats hired to transport patrons to distant shores, such as Shale Point, for an afternoon of picnicking and leisure.

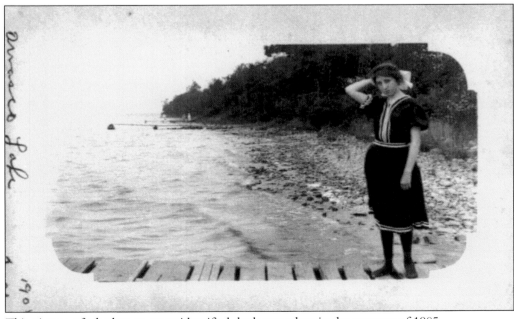

This picture of a bather on an unidentified dock was taken in the summer of 1905.

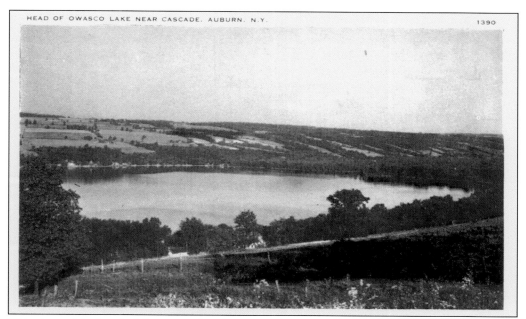

This view of the head of Owasco Lake, the area at the south end, shows the village of Moravia in the valley to the right. It was taken when vast farms still lined the shores.

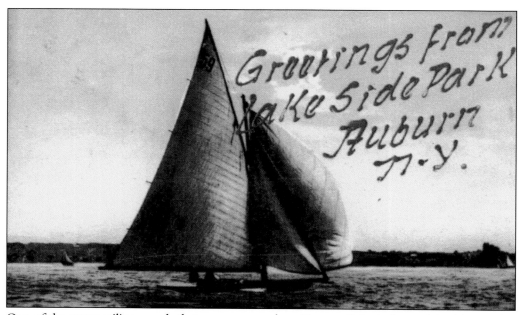

One of the many sailing vessels that once appeared on Owasco Lake is featured in this greeting postcard from Auburn.

85

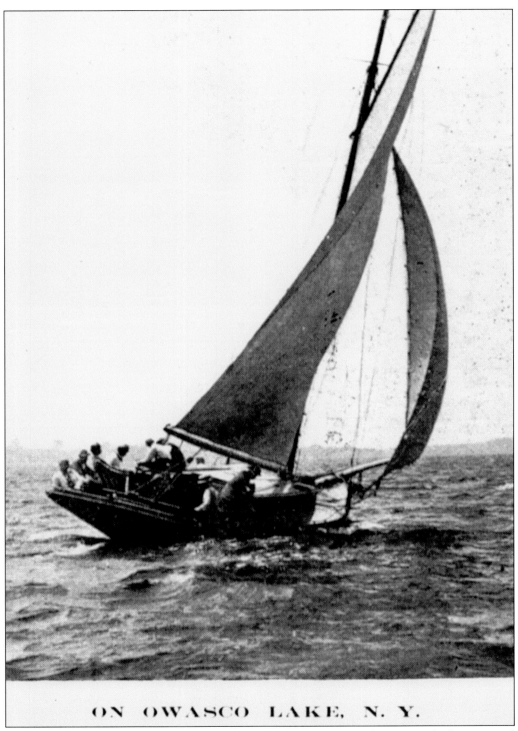

ON OWASCO LAKE, N. Y.

The early sailing rigs on Owasco Lake were made from wood, with canvas sails that required intimate knowledge of the winds and weather for a successful ride, as seen in this 1909 postcard.

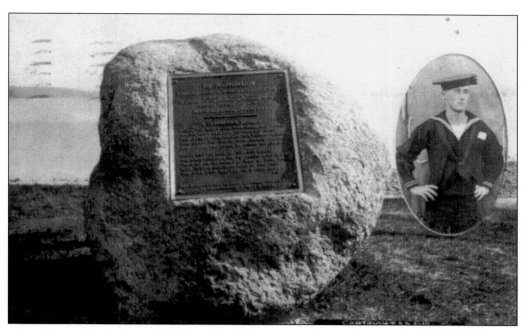

The rock at Emerson Park today is a well-known landmark. It bears a plaque in memory of a young sailor who lost his life attempting to save a drowning victim just off the shores of the park.

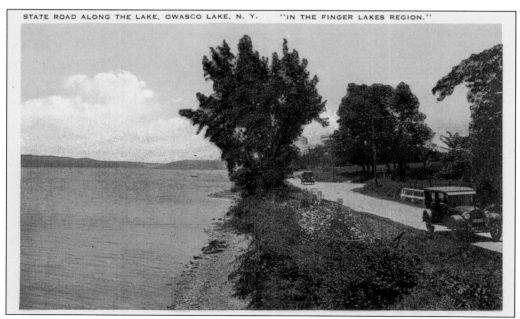

State roads offered little or no protection for the early motorists who made their way around the lake along dirt roads.

The age of motorboats was inaugurated on Owasco Lake somewhat earlier than on the other Finger Lakes due to the pioneering techniques and experimental boats worked on and built by Ed Hinton and others.

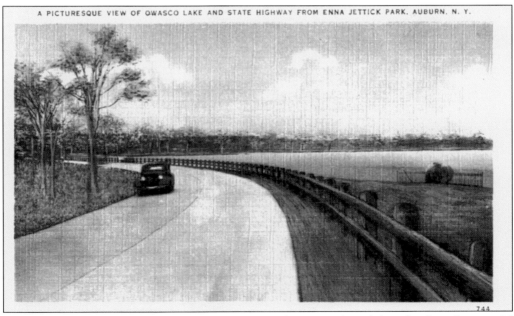

A PICTURESQUE VIEW OF OWASCO LAKE AND STATE HIGHWAY FROM ENNA JETTICK PARK, AUBURN, N. Y.

This familiar curve at Emerson Park is today a two-lane, paved road, but the fenced memorial rock remains, as does the popular sandy beach.

Five

CLUBS AND CAMPS

Clubs, summer camps, and recreational organizations have a long past on the shores and waters of Owasco Lake. They began in the 1860s when the fad became rowing. A rowing race in 1867 prompted the Dolphin Boat Club by 1870 to organize; club members specialized in rowing eight-man canoes the entire length of the lake. Prominent Auburnians were able to build impressive clubhouses and camps along the lake, one of which still exists at Dolphin Point.

Summer residential camps for young boys and girls have been a fixture on the lake since the start of the 20th century. These camps often adapted former summerhouses into camping facilities with boating, sailing, swimming, archery, and other outdoor activities. Several religious camps also dotted the shores in the past, including Casowasco, a popular Methodist camp still in existence. Other fixtures on the lake, still enjoyed by their members today, include the Owasco and Auburn Country Clubs and the Owasco Yacht Club.

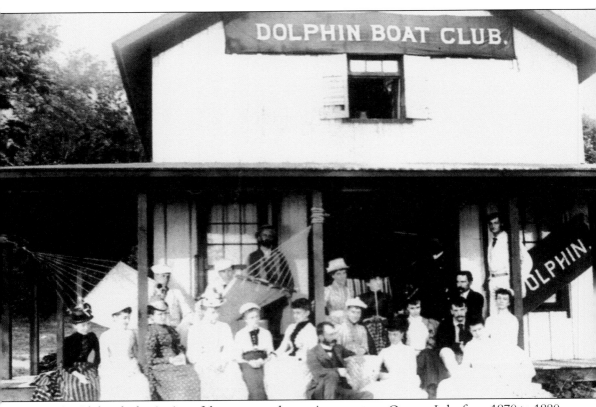

It is said that the beginning of the very popular rowing events on Owasco Lake from 1870 to 1880 began in 1867 with the formation of three rival rowing clubs, including the Dolphin Boat Club. This is the Dolphin clubhouse, on Peacock's Point (renamed Burr's Point in 1887). (Courtesy Seward House Archives.)

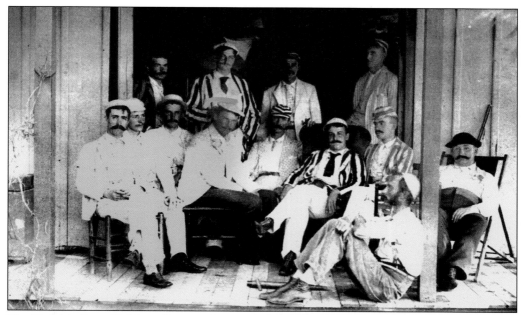

The Dolphin Boat Club's earliest members included William and Edwin Kirby, Henry D. Titus, Frank Wright, Thomas Towne, Richard Holmes, and Joseph Steel, who had come into possession of a 38-foot rowing cutter named the *Dolphin*. (Courtesy Seward House Archives.)

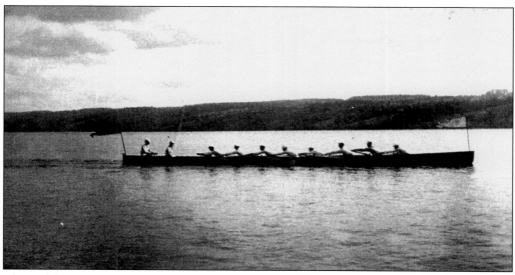

The *Dolphin* cutter is seen here in full way. The massive boat was stored in the Dolphin Boat Club's new boat shed on the eastern side of the outlet near the dam while the club built a retreat and house at Peacock's Point in the 1870s. (Courtesy Seward House Archives.)

The Dolphin Boat Club members are shown at their old house on Peacock's Point in the 1870s. In the summer of 1870, much to the delight of local media, they had actually taken their boat on a 34-day adventure through the Seneca River, Lake Ontario, the St. Lawrence Seaway, Lake Champlain, and the Hudson River. (Courtesy Seward House Archives.)

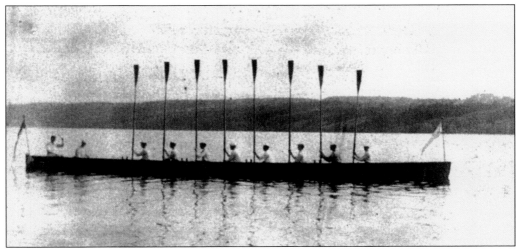

The Dolphin Boat Club called Peacock's Point home until 1887 when Charles Burr purchased the land and renamed it Burr's Point. The club spent three summers on the eastern shore at Ward's Point, before purchasing land south of Seward's Point, today known as Dolphin Point. There, in 1890, they erected an elaborate clubhouse, boathouse, icehouse, and landing pier for the rowing canoe and newly acquired steamship. The dark green house and clubhouse can still be seen on the point today. (Courtesy Seward House Archives.)

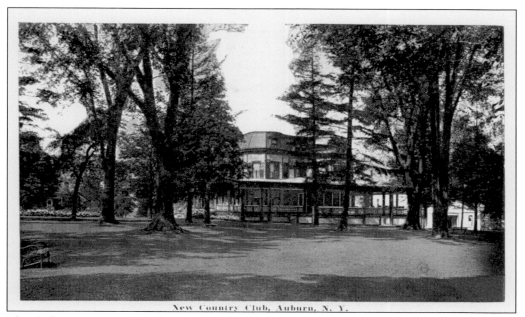

The Auburn Country Club built this impressive Mansard-styled clubhouse atop the hill in Owasco, overlooking Owasco Lake in the 1890s.

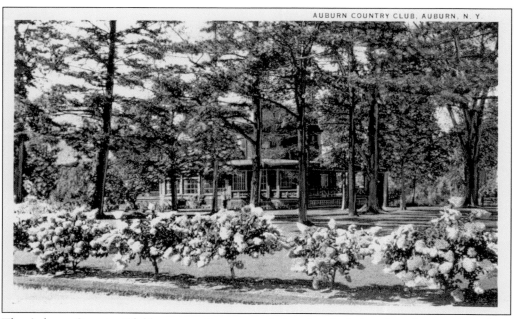

The Auburn Country Club's surroundings were designed to include a luxurious garden, along with the prerequisite golf course.

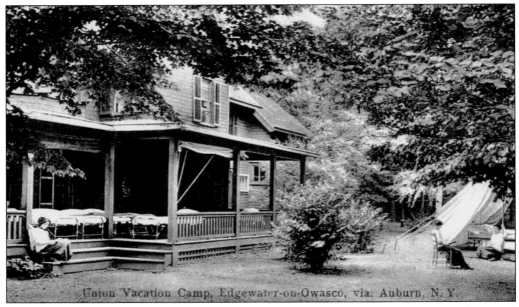

The Union Vacation Camp at Edgewater-on-Owasco was the camp of the Women's Educational Industrial Union, which operated a Girl Scout camp at the site for many decades. The union and the YMCA later merged. The Girl Scout camp is now just south of the YMCA camp on the east side of the lake.

Located about six miles from Moravia on the lake's east shore, Edgewater featured a shale beach and a myriad of boating activities such as sailing, canoeing, and even "floating lunches." The site was purchased in 1912.

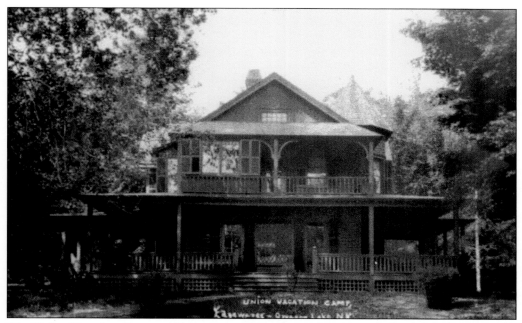

The Union Vacation Camp at Edgewater could accommodate 25 to 30 families each summer. It remained in operation until 1967.

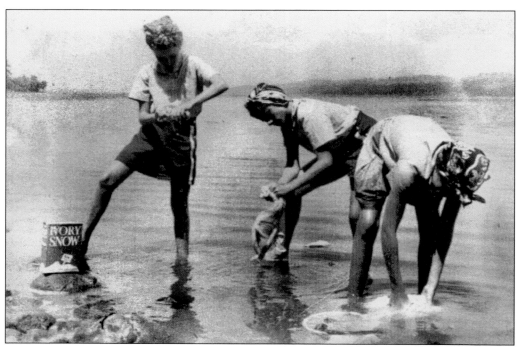

The Cayuga County Girl Scouts utilized the Union Vacation Camp at Edgewater in August 1941, as seen here on washing day, which was done in the lake itself. (Courtesy Cayuga Museum.)

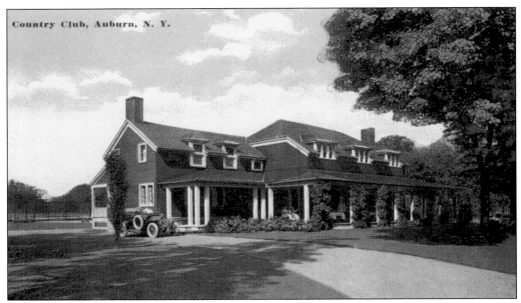

The Owasco Country Club has stood at the foot of Owasco Lake since *c.* 1910. Over the years, its clubhouse has been expanded and remodeled several times.

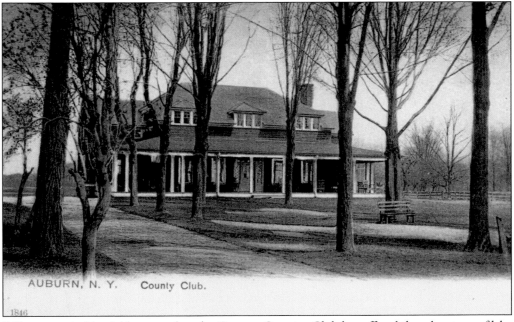

Still a recognizable clubhouse today, the Owasco Country Club has offered the advantage of lake views from its beginning.

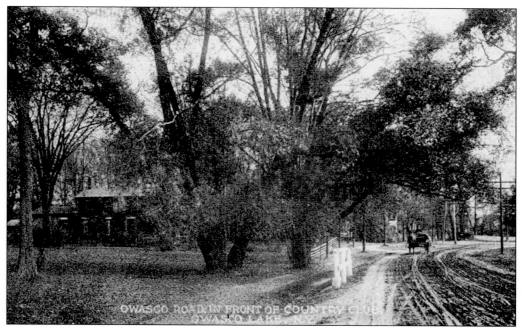

This postcard of the road in front of the Owasco Country Club was sent in 1912. It shows a rather muddy road and the rural nature of the site at the time.

A lone canoe is pictured near the upper eastern shore of Owasco Lake long before the shoreline became lined with summer cottages and houses.

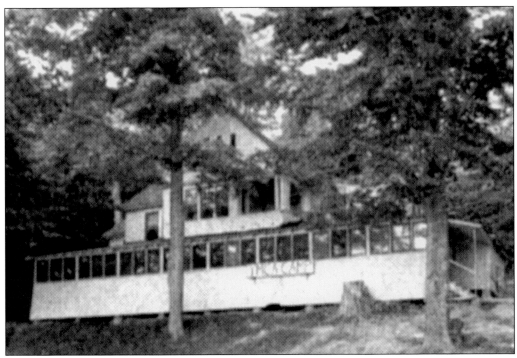

For a total cost of $3,461.78, the YMCA of Auburn purchased at auction the former Thorne property on Owasco Lake in 1924. The Y then converted it into a summer camp for boys.

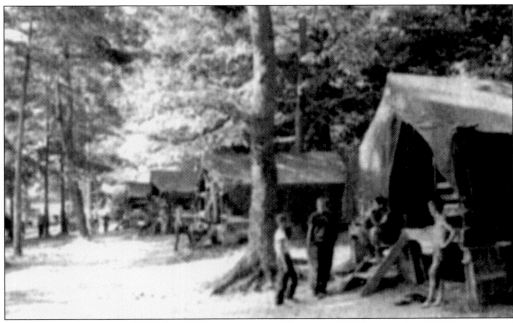

Tents were the way of life for many summer residents. In 1924, a total of 200 boys were enrolled for the summer at the YMCA camp, located about 10 miles north of Moravia on the eastern shore.

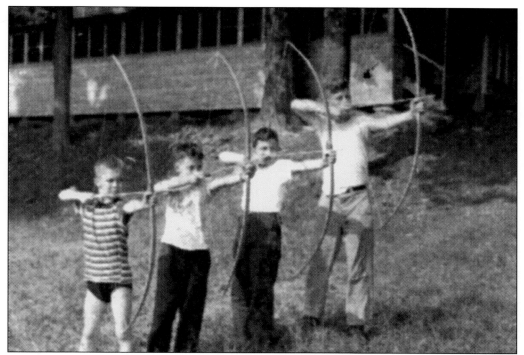

The boys at the YMCA camp were taught archery, swimming, and other outdoor activities, as well as the lesson that "profanity, dirty talk, selfishness, grouchiness, and meanness" were to be avoided.

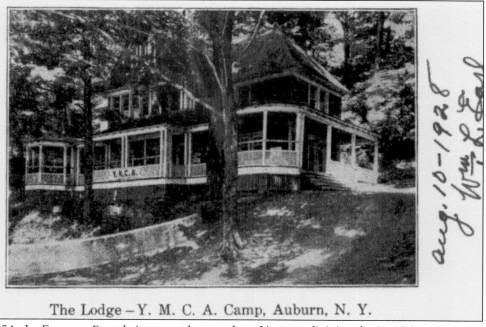

The Lodge — Y. M. C. A. Camp, Auburn, N. Y.

In 1954, the Emerson Foundation agreed to purchase 31 acres adjoining the YMCA property on the south, vastly expanding the summer camp.

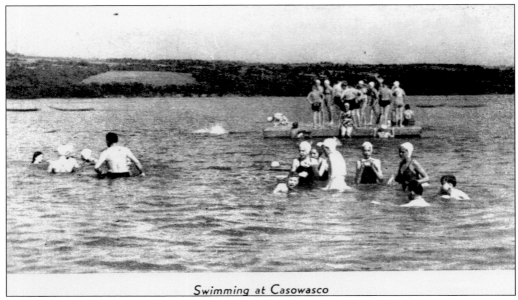

Swimming at Casowasco

Casowasco, a large summerhouse built in 1896 by Theodore Willard Case, became a popular Methodist camp in 1949. The camp is still in operation today.

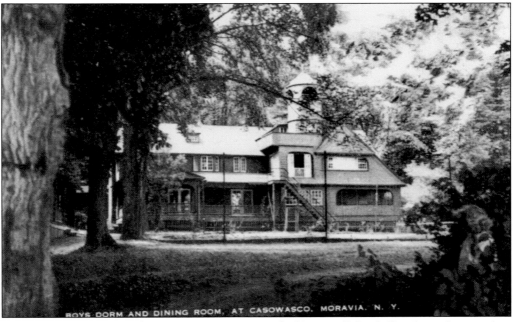

BOYS DORM AND DINING ROOM, AT CASOWASCO, MORAVIA, N. Y.

The boys' dormitory and dining room at Casowasco had been a dining hall and guesthouse when it was part of the Case summer home. This building was torn down and replaced in the 1970s.

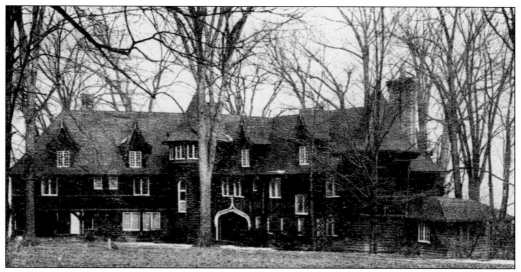

The name of Willard Case's home, Casowasco, was formed from a combination of his last name and the name of Owasco Lake. The summer camp that now occupies the property retained the name.

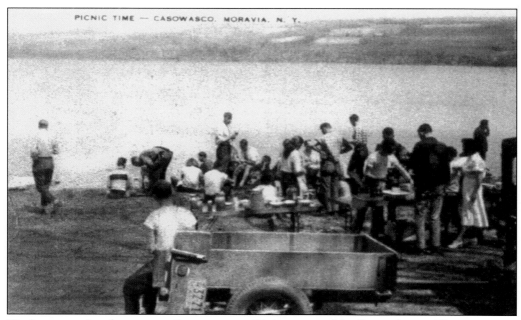

PICNIC TIME — CASOWASCO. MORAVIA. N. Y.

Picnic goers enjoy the scene at Casowasco, as did the guests of the former home. The estate even featured its own railroad stop, which is still on the property today and used as a woodshed.

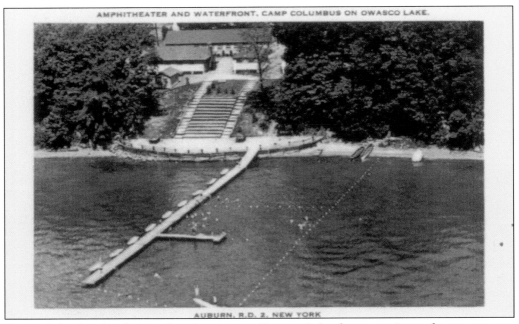

Camp Columbus has been a favorite spot on Owasco Lake for generations of summer camp goers.

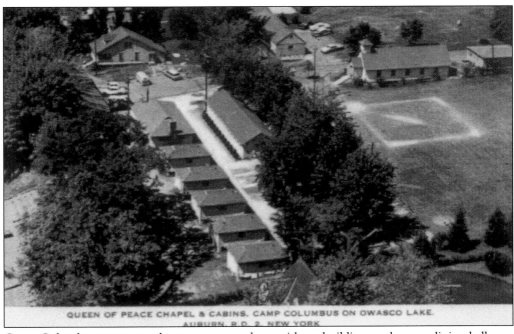

Camp Columbus was once a large estate, seen here with outbuildings and group dining halls.

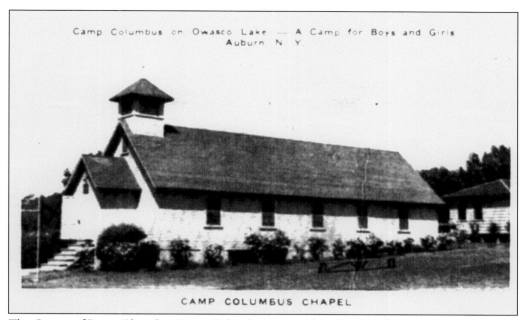

CAMP COLUMBUS CHAPEL

The Queen of Peace Chapel at Camp Columbus is one of the few buildings on the campsite that remains to this day. It is used as a summer residential camp for mentally challenged adults.

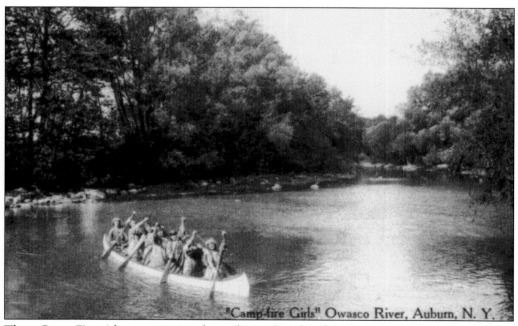

These Camp Fire girls are traversing the outlet, with eight of them in one canoe.

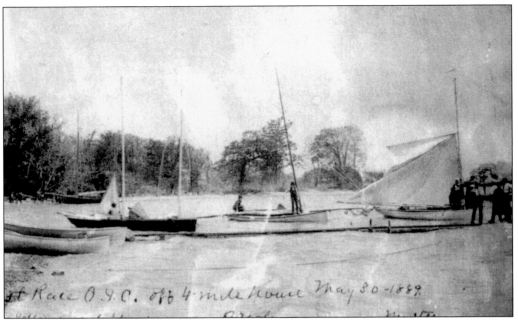

The Owasco Yacht Club held its first race on Owasco Lake on May 30, 1889, off the "Four Mile House" on the lake's western shore.

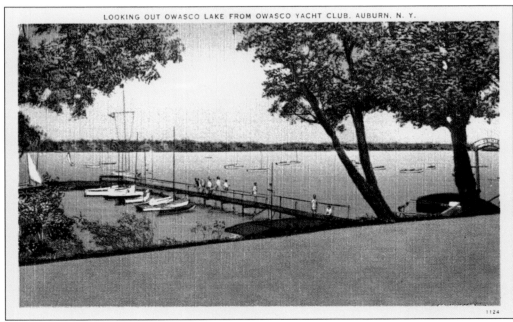

LOOKING OUT OWASCO LAKE FROM OWASCO YACHT CLUB. AUBURN. N. Y.

The Owasco Yacht Club was originally located on the lake's west shore just south of Buck Point. The cement pier can still be seen today. The club moved to a point just across the lake south of Martin's Point in the 1970s.

Six

HOUSES AND
LAKE ESTATES

The shores of Owasco Lake have served as the site of homes and summer estates for nearly 200 years, with the first perhaps being that of Gov. Enos Throop, built on today's Martin's Point in 1818. Congressman Sereno Payne also had a summer home on the lake, as did William Seward Jr., at which the founders of the American Express Company would often meet. The boyhood home of John D. Rockefeller was once prominently located atop a hill overlooking Owasco Lake. Inventor Theodore Case spent many seasons at his summer home, Casowasco, on the western shore.

Not all homes along the lake were large and luxurious. In fact, most were smaller elegant wood-framed summer cottages with wide porches and close neighbors, all positioned to take advantage of cool summer breezes. Some camps were just a summer tent for a quick getaway. Only in the past two decades has the trend of converting summer homes to year-round residences begun to alter the summer-only experience of the lake.

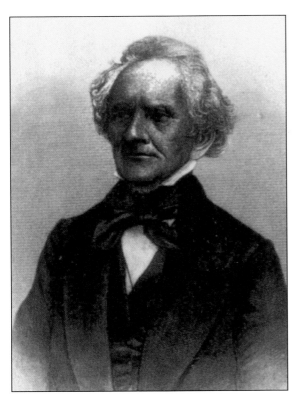

A two-time governor for New York from 1829 to 1832, Enos T. Throop was perhaps one of the more famous residents of Owasco Lake.

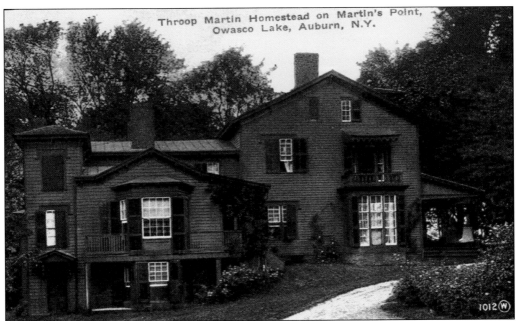

Throop's "Willowbrook" was built in 1818 on what is today's Martin's Point, just south of Auburn. There, he entertained Ulysses S. Grant and Secretary of State William Seward, among others.

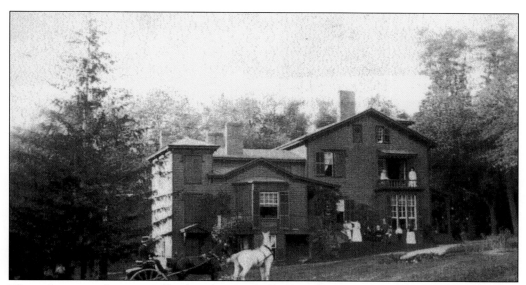

Throop's summerhouse, Willowbrook, eventually passed on to his relative Edward Sanford Martin and became known as Martin's Point. The house existed until sometime after 1965.

Edward Martin grew up at Martin's Point and was the creator of the *Harvard Lampoon* and, along with Harvard University friends, the creator of *Life* magazine.

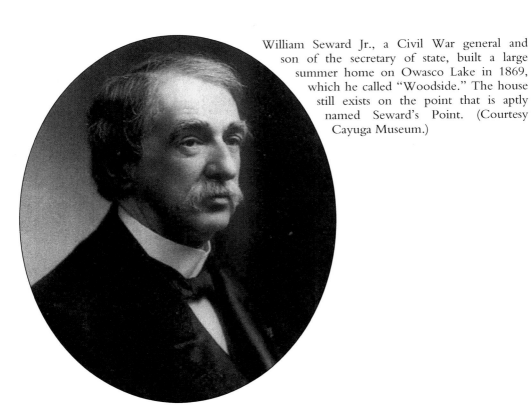

William Seward Jr., a Civil War general and son of the secretary of state, built a large summer home on Owasco Lake in 1869, which he called "Woodside." The house still exists on the point that is aptly named Seward's Point. (Courtesy Cayuga Museum.)

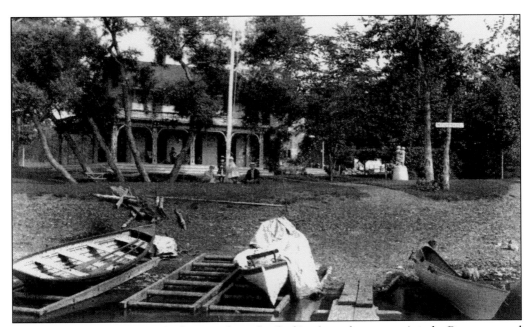

Woodside was built close to the homes of two family friends on the same point: the Pomeroys and the Allens. Those two homes remain to this day. The ornate porch of the Seward home is seen here in the center. (Courtesy Seward House Archives.)

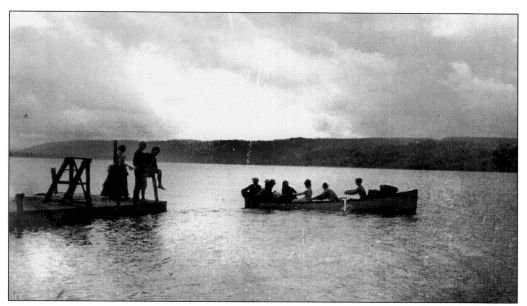

Transportation to and from Woodside was primarily by boat or by a steamship that the three families shared. (Courtesy Seward House Archives.)

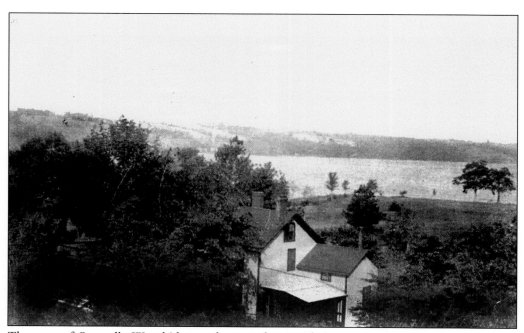

The rear of Seward's Woodside can be seen here with its spectacular view from the lake. Congressman Theodore Medad Pomeroy's house was located to the south and F.I. Allen's to the north. (Courtesy Seward House Archives.)

Seward's house can be seen here with the Pomeroy house in the background. Secretary of State William H. Seward Sr. was known to have visited the house in 1872. (Courtesy Seward House Archives.)

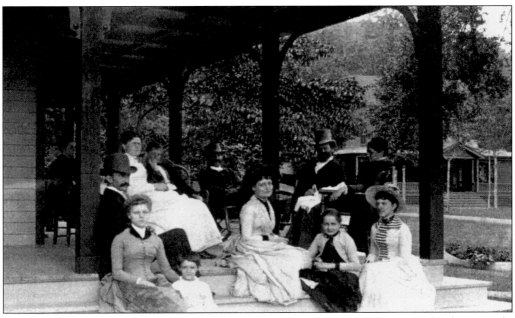

Prominent Auburnians were frequent visitors to Woodside, including these on the front porch: the Knapps, the Beardsleys, and a Miss Richards. (Courtesy Seward House Archives.)

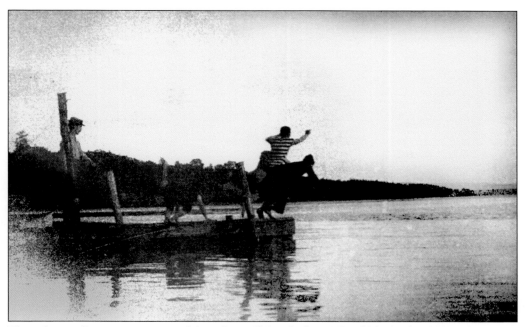

These brave divers were captured jumping off the dock at Woodside in the 1880s. (Courtesy Seward House Archives.)

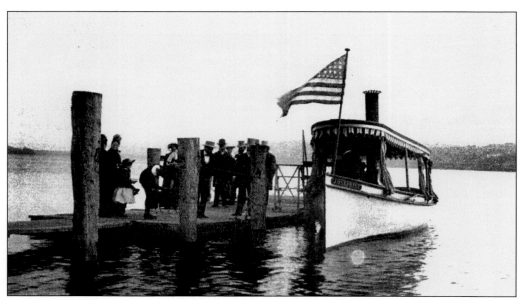

Theodore Medad Pomeroy was one of the founders of the American Express Company. The company's other founders are seen leaving Woodside to board the steamer *St. Josephine*. (Courtesy Seward House Archives.)

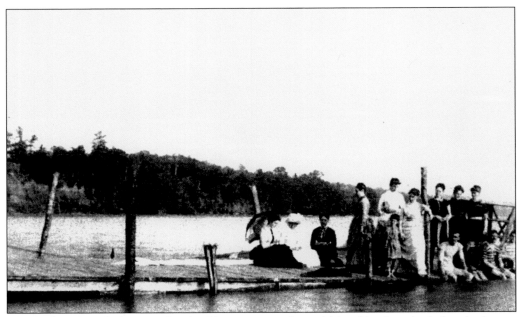

The dock at Woodside seems barely able to support these visiting friends and relatives in August 1885. (Courtesy Seward House Archives.)

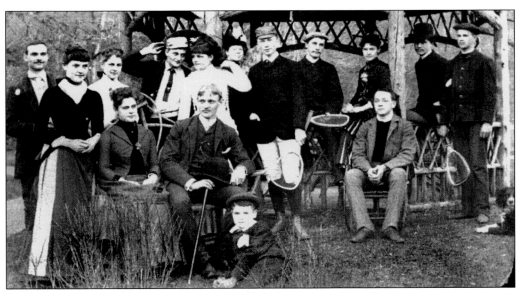

This group of unidentified guests was captured visiting the gazebo at the Pomeroy summerhouse in May 1886. (Courtesy Seward House Archives.)

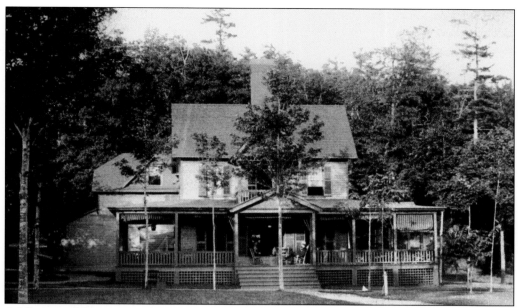

A full view of the Pomeroy house at Woodside shows the large summer living quarters available to those prominent Auburnians who could afford such luxury. (Courtesy Seward House Archives.)

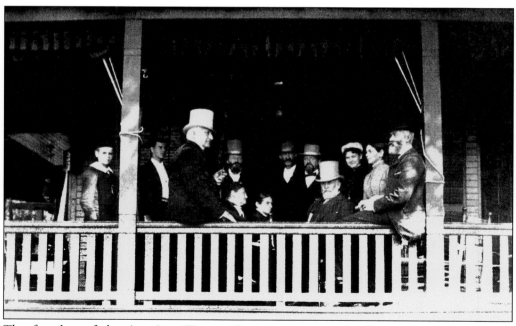

The founders of the American Express Company meet at the Pomeroy summerhouse in the summer of 1887 to discuss the emerging company's plans for the future. (Courtesy Seward House Archives.)

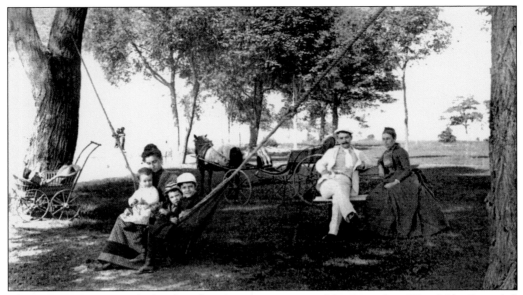

This rope swing was undoubtedly a favorite among guests of the Sewards at Woodside. From left to right are Cornelia Seward Allen and her three sons, her husband, and Janet Watson Seward (Mrs. William Seward Jr.). (Courtesy Seward House Archives.)

Auburn, N. Y., Owasco Lake, near Woodside

This idyllic point just south of Woodside reveals the rocky shore that is characteristic of Owasco Lake's southern end.

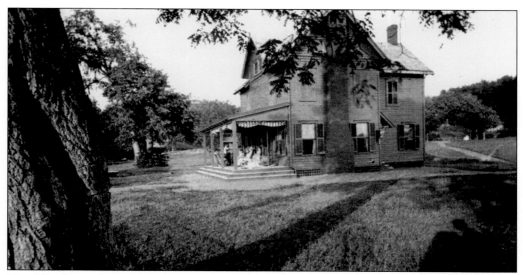

The Allen house, just north of Woodside, originally featured elegant striped canvas on its porch to offer shade from the sun during hot summer afternoons. (Courtesy Seward House Archives.)

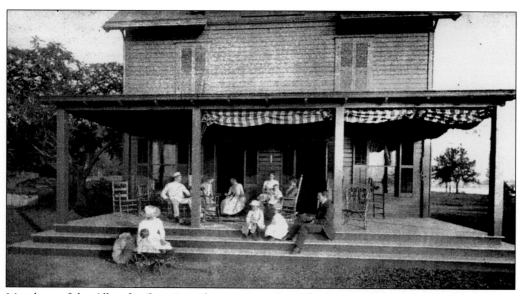

Members of the Allen family enjoy a lazy summer day. The house still exists but in an expanded and altered state. (Courtesy Seward House Archives.)

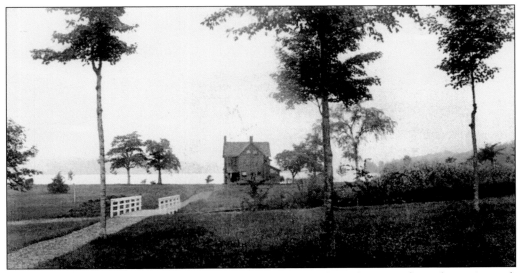

The approach to the Allen house at Woodside included a long driveway from the main road, terminating at an elegant wooden bridge. (Courtesy Seward House Archives.)

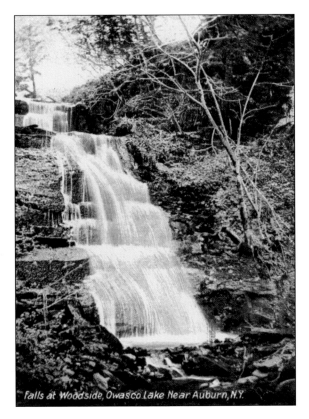

Falls at Woodside, Owasco Lake Near Auburn, N.Y.

Most of the early homes built along the shores of Owasco Lake were constructed near streams and brooks, which commonly featured a waterfall, as did the three homes clustered on Seward's Point.

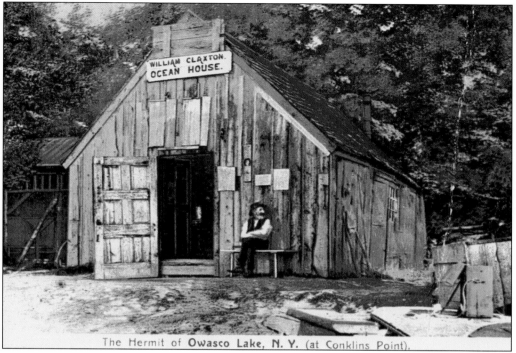

The Hermit of **Owasco Lake, N. Y.** (at Conklins Point).

Billy Claxton was known as the hermit of Owasco Lake. He lived in this shack at Conklin's Point. Often hired by visitors as a fishing guide, he also sold candy and fish bait to area youngsters. A veteran of the Civil War, he lived to be nearly 100 years old.

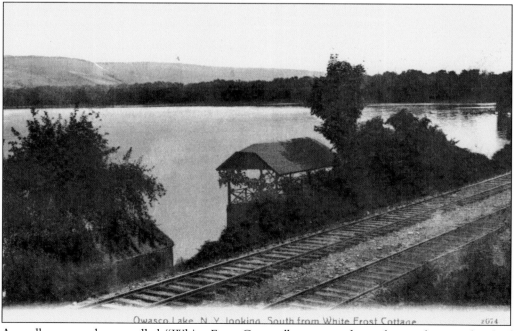

Owasco Lake, N. Y. looking South from White Frost Cottage.

A small summer home called "White Frost Cottage" was once located near the very head of Owasco Lake, not far from Cascade.

The Dunning family named their Owasco Lake summer home "Hazelwood." The house once stood about a mile south of Ensenore. (Courtesy Seward House Archives.)

This elegant house at Glenwood Beach has been a landmark on Owasco Lake for nearly 100 years. It is located about halfway down the lake on the west side. (Courtesy Seward House Archives.)

These fine summer cottages once stood at Letchworth's Point, a popular summer retreat. The point was formerly known as Glenwood Point. (Courtesy Seward House Archives.)

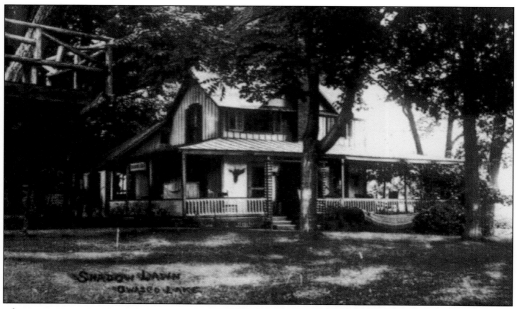

The message on this postcard notes that the house was coined "Shadow Lawn" for obvious reasons. It is unknown where the house stood, but it did feature a rather large tree-house structure, seen at the left.

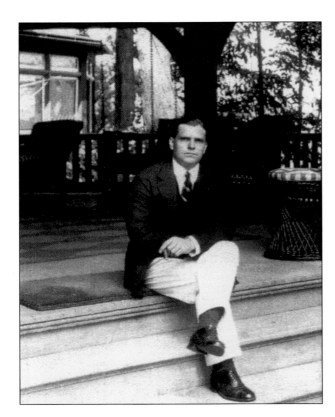

Theodore Willard Case is seen here on the steps of his summer mansion, Casowasco, which was built in 1896. (Courtesy Cayuga Museum.)

Casowasco was enjoyed by the Case family from the time it was built in 1896 to 1942 when it was sold and reconfigured into a Methodist camp by the same name.

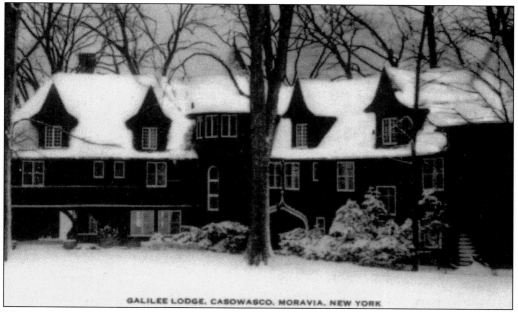

GALILEE LODGE, CASOWASCO, MORAVIA, NEW YORK

The unusual curves of Casowasco were designed to conform to the curved shoreline, and the estate featured a variety of outbuildings, servants' quarters, and even its own railroad stop.

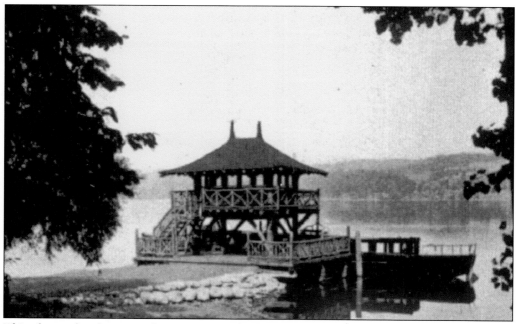

This elegant boathouse at Casowasco was built in 1896 in a rustic style more typical of the Adirondack region of New York State. Note the steamer at the pier waiting to ferry passengers to Auburn.

This unusual view from the bell tower at Casowasco was taken by family friend William Seward Jr., who resided across the lake from the Case family. (Courtesy Seward House Archives.)

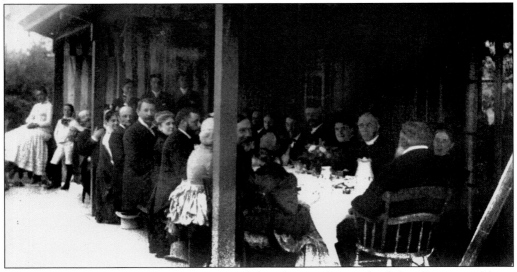

William Seward Jr. snapped this picture of friends enjoying a clambake dinner outside at Willow Point, an unusual dinner location for the formal era. It was the home of D.M. Osborne of Auburn, and it was located halfway between Ensenore and Cascade. (Courtesy Seward House Archives.)

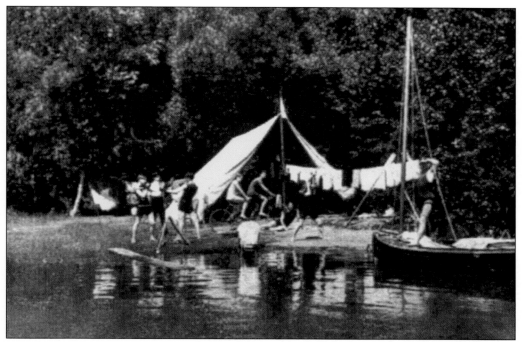

Not all summer camps were large and luxurious. These campers are indeed camping it up at Indian Cove, showing off their boxing, bicycling, sailing, sunbathing, and laundry skills.

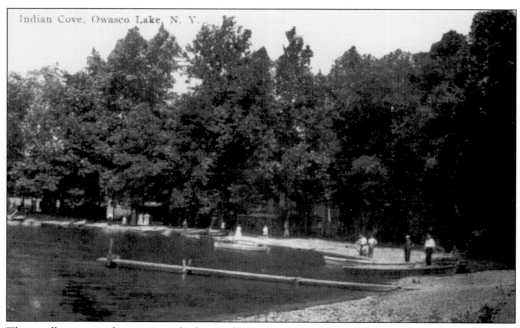

Indian Cove, Owasco Lake, N. Y.

The small camps and precarious dock at Indian Cove were captured in this postcard sent in 1909. (Courtesy Peter Bauman.)

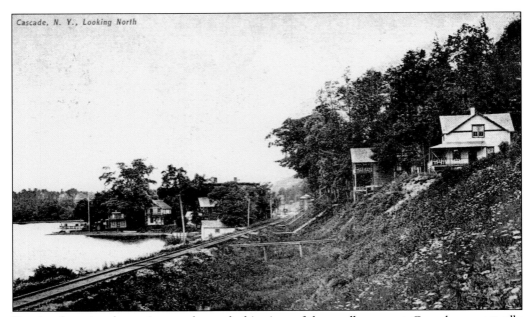

Despite the printed notation on the card, this view of the small camps at Cascade was actually taken looking south.

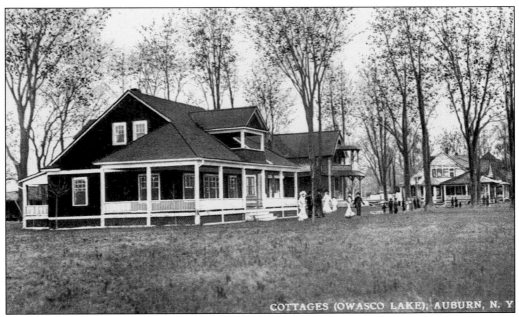

These cottages are still located at the foot of Owasco Lake along the road across from Emerson Park.

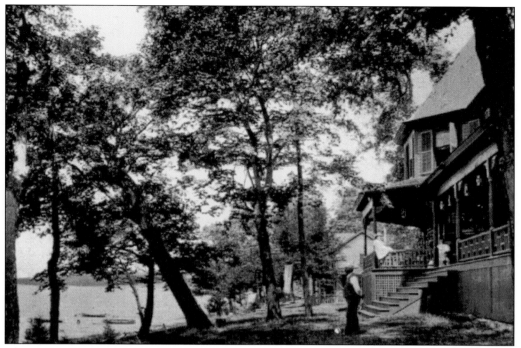

This unidentified house was once located on the shores of Owasco Lake, one of the many fine homes built *c.* 1900.

Very low lake levels are seen in this postcard of a humble camp on the east side of Owasco Lake, whose dock was left high and dry.

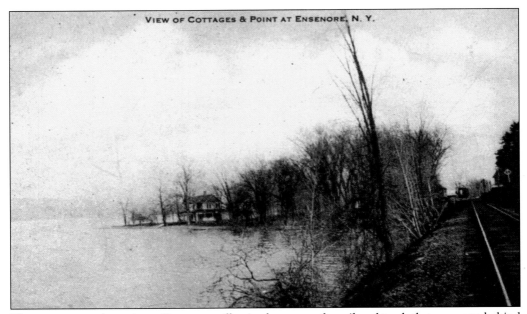

VIEW OF COTTAGES & POINT AT ENSENORE, N. Y.

The cottages on the point at Ensenore still exist; however, the railroad track that once ran behind them is long gone.

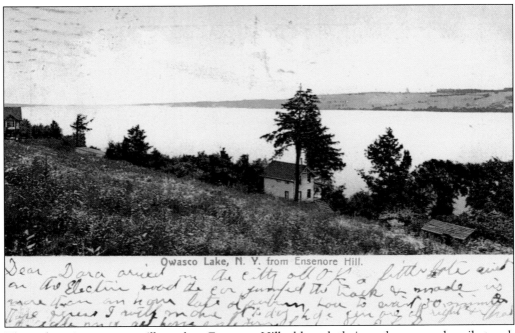

Owasco Lake, N. Y. from Ensenore Hill.

These charming cottages still stand on Ensenore Hill, although their yards are now heavily treed.

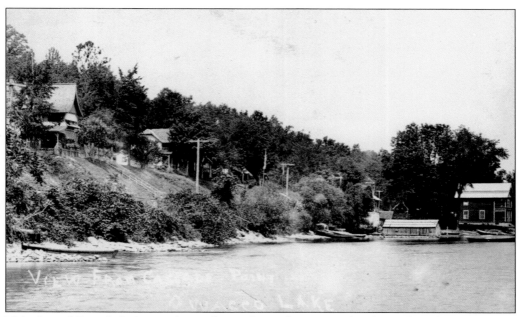

This view of Cascade Point, on the southwest shore of Owasco Lake, shows the rather typical row of late-1890s cottages that once lined the area.

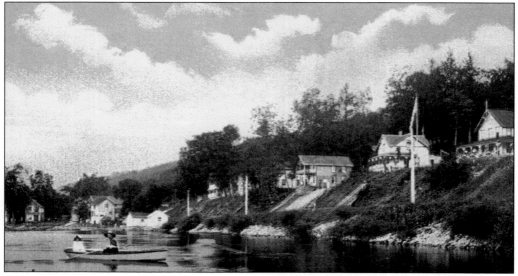

Elegant cottages with wide front porches once lined the shores of the hamlet of Cascade.

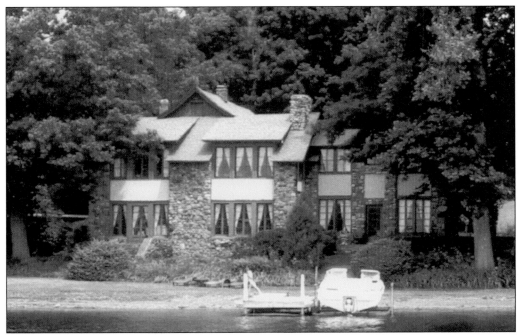

This contemporary picture shows the summer cottage that once belonged to writer Samuel Hopkins Adams. In the 1920s, Adams expanded an older family camp, the roof of which can be seen peeking out from behind the stone addition.

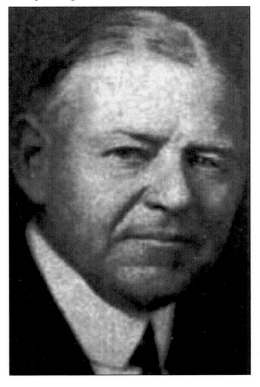

Author Samuel Hopkins Adams (1871–1958) lived year-round on Owasco Lake in the 1920s and was the area's most famous writer at the time, authoring numerous books, articles, and columns. (Courtesy Library of Congress.)